PORTRAIT OF
THE OZARKS

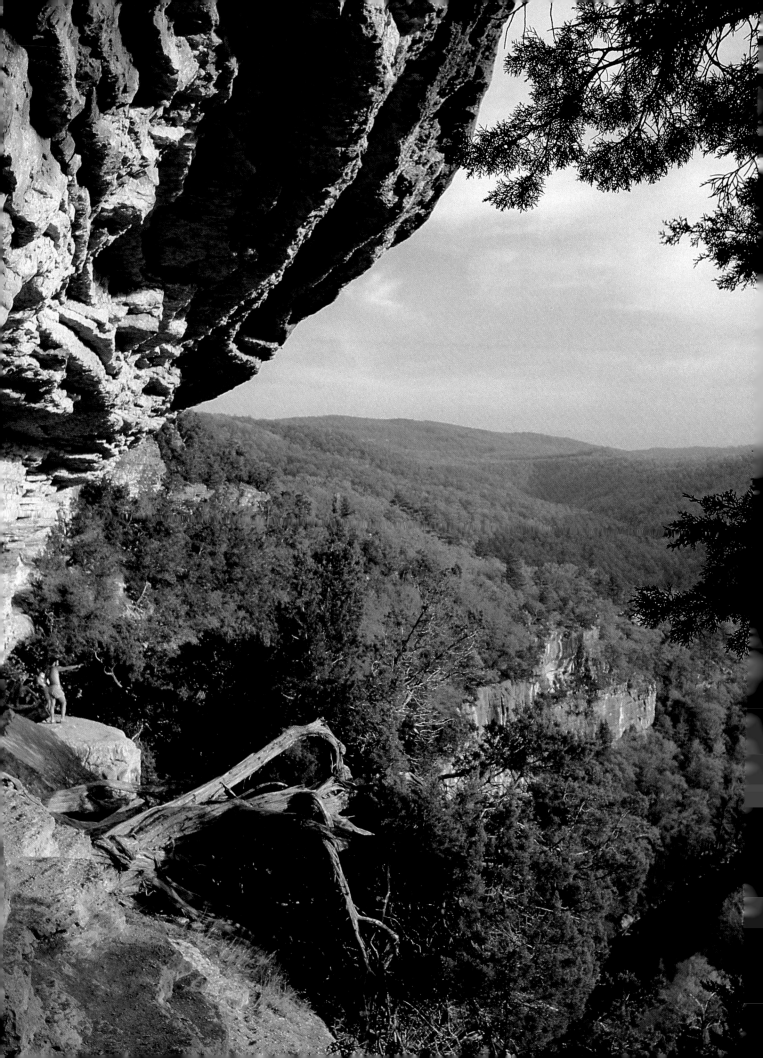

PORTRAIT OF
THE OZARKS
DAVID FITZGERALD

TEXT BY CLAY ANDERSON

GRAPHIC ARTS CENTER PUBLISHING™

International Standard Book Number 1-55868-205-8
Library of Congress Catalog Card Number 94-73055
Photographs Copyright © MCMXCV by David Fitzgerald
Text and Captions Copyright © MCMXCV by Graphic Arts Center Publishing Company
P.O. Box 10306 • Portland, Oregon 97210 • 503/226-2402
President • Charles M. Hopkins
Editor-in-Chief • Douglas A. Pfeiffer
Managing Editor • Jean Andrews
Production Manager • Richard L. Owsiany
Typographer • Harrison Typesetting, Inc.
Printer • Color Magic Inc.
Bindery • Lincoln & Allen
Printed and bound in the United States of America

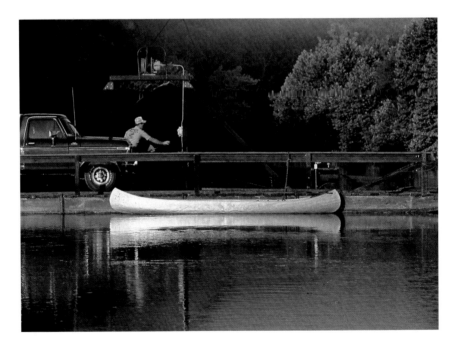

Front cover photograph: Shortly after 1900, a minister and writer, Harold Bell Wright "discovered" the Ozarks and wrote *The Shepherd of the Hills* on this homestead near Branson, Missouri. *Frontispiece photograph:* Called the Goat Trail, a ledge along Big Bluff near Ponca, Arkansas, provides breathtaking views of the Buffalo River. *Above:* Current-powered ferries were common in the Ozarks a few decades ago. Now, only this one on the Current River in Shannon County, Missouri, and a handful of others remain. *Back cover photograph:* A thunderstorm gathers force over Table Rock Lake.

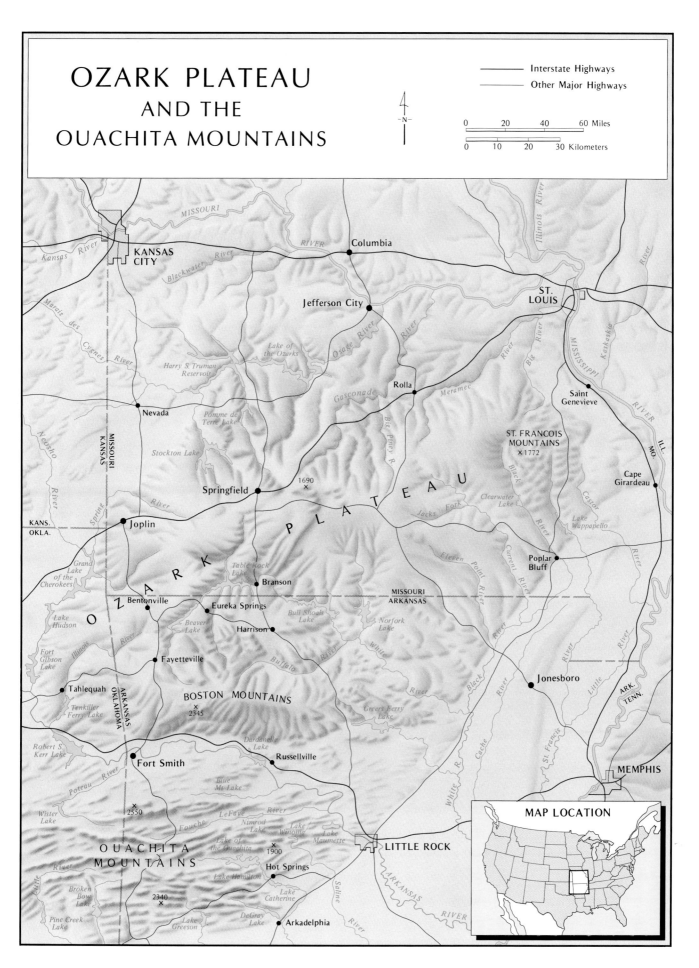

OZARK PLATEAU
AND THE
OUACHITA MOUNTAINS

N

Interstate Highways
Other Major Highways

0 20 40 60 Miles
0 10 20 30 Kilometers

MISSOURI

Kansas River

KANSAS CITY

Blackwater River

RIVER

Columbia

Marais des Cygnes River

Jefferson City

Osage River

River

ST. LOUIS

MISSISSIPPI

Kaskaskia

MISSOURI
KANSAS

Lake of the Ozarks

Gasconade

Rolla

Meramec

River

Big River

RIVER

Saint Genevieve

ILL.
MO.

Nevada

Pomme de Terre Lake

Harry S. Truman Reservoir

Stockton Lake

Gasconade

Big Piney R.

ST. FRANCOIS MOUNTAINS
×1772

Black River

Cape Girardeau

Neosho River

Spring River

1690
×

Springfield

P L A T E A U

Jacks Fork

Clearwater Lake

Lake Wappapello

Castor River

KANS.
OKLA.

Joplin

O Z A R K

Eleven Point River

Current River

Poplar Bluff

River

Grand Lake of the Cherokees

Table Rock Lake

Branson

MISSOURI
ARKANSAS

Lake Hudson

Bentonville

Eureka Springs

Bull Shoals Lake

Norfork Lake

Fort Gibson Lake

Beaver Lake

Harrison

White River

Black River

Jonesboro

Little River

ARK.
TENN.

Tahlequah

Illinois River

OKLAHOMA
ARKANSAS

Fayetteville

Buffalo River

BOSTON MOUNTAINS
×2345

Greers Ferry Lake

River

Cache River

St. Francis River

Tenkiller Ferry Lake

Robert S. Kerr Lake

Poteau River

Fort Smith

Dardanelle Lake

Russellville

White R.

MEMPHIS

Wister Lake

2550
×

Blue Mt. Lake

LeFave River

Fourche

Nimrod Lake

Lake Winona

Lake Maumelle

LITTLE ROCK

MAP LOCATION

OUACHITA MOUNTAINS

Lake of the Ouachita

1900
×

Hot Springs

Lake Hamilton

Saline River

ARKANSAS RIVER

River

Broken Bow Lake

2340
×

Lake Catherine

DeGray Lake

Pine Creek Lake

Lake Greeson

Arkadelphia

5

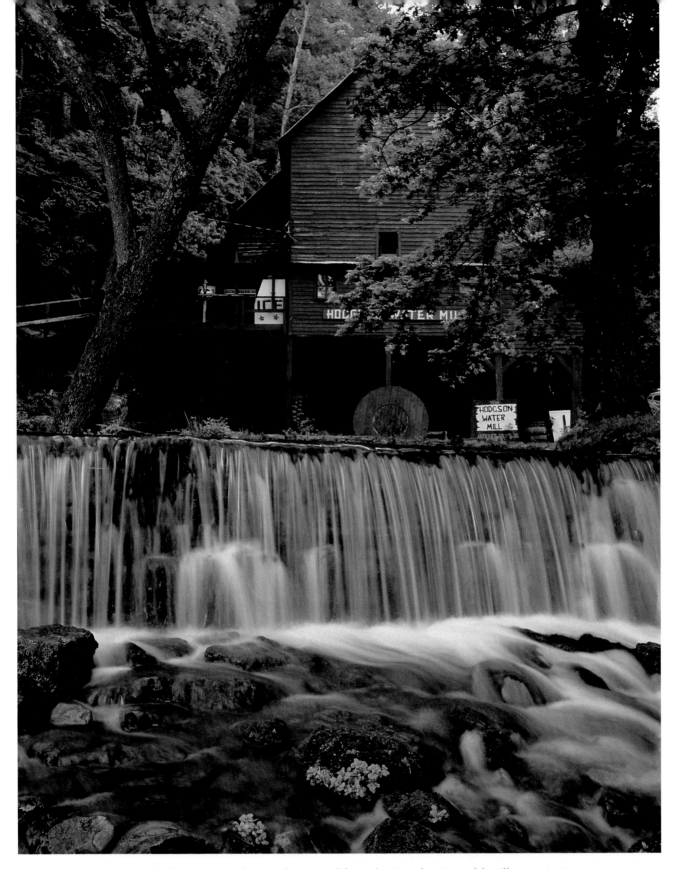

▲ Grist mills were a vital part of pioneer life in the Ozarks. Five old mills remain in Ozark County, Missouri, finally reached by paved roads in the 1950s. Flowing twenty-three million gallons daily, a spring has powered Hodgson Water Mill since the Civil War. The mill's trademark appears on buhrstone-ground products sold nationwide.

The Ozarks
by Clay Anderson

INTRODUCTION. When I was living in the sprawling Chicago metropolitan area and pining to be in the Ozarks, one day I came across a very tiny newspaper advertisement buried in the paper. The small headline declared: "All the lies they tell about the Ozarks are true."

That statement was as much of an enigma as my own feelings. What was this longing within me? I grew up in the hills of southeast Missouri. I visited relatives living at Bonne Terre in the "Lead Belt," my Uncle Roy Magill took me fishing on the St. Francis and Black Rivers, and my mother's family gathered at places like Big Spring, Lake Killarney, Mine La Motte, and Castor River for picnics and outings. Lakes were few and far between in the Ozarks when I was a boy, and Lake Killarney was an aqueous jewel set miraculously in the St. Francois Mountains. When I went back in later years, Lake Killarney was something of a disappointment, but Big Spring is magnificent to this day.

Experts estimate that Big Spring, a cold river appearing to boil out of the base of a rugged hill, has had a maximum flow of 840 million gallons a day, the largest flow in the United States and one of the largest in the world. Big Spring emerges from the wreckage of a cave outlet and, on an average day, discharges 276 million gallons, which makes it tops in a region particularly noted for its springs.

But life in the Ozarks was typified more by small springs, the kind people sheltered with spring houses and used as natural refrigeration for milk, cream, butter, eggs, and fresh produce. That, for me, represented the Ozarks way of life, and the personification of that way of life was Uncle Bill Anderson.

Uncle Bill was a route mail carrier in Kansas City in the 1930s when he began to yearn for the Ozarks. With his family and another couple there were many trips to the Osage River in the Warsaw, Missouri, area. Sometime in the early 1930s, about the time Lake of the Ozarks began filling, Uncle Bill decided where he wanted to be.

He advertised in a postal paper his willingness to trade his city route for one in the Ozarks, received a favorable reply, and moved his family into a house near Brumley, Missouri. The family farmed and gardened, kept livestock, and worked hand in hand with their neighbors. Of course, Uncle Bill carried the mail, over rough country roads punishing to vehicles. When he could not cover the route otherwise, he would resort to horseback.

Even with farming and carrying the mail, Uncle Bill always found time for fishing. Lake of the Ozarks was relatively new, and the fishing was great. Bagnell Dam, built by Union Electric Company, had impounded some sixty-five thousand acres of water surface with thirteen hundred miles of shoreline. It was the second of the large man-made lakes in the Ozarks, but it was far larger than its predecessor, Lake Taneycomo, created in 1913 by the Powersite Dam, which was built on the White River, near Forsyth, Missouri.

Later, Uncle Bill and Aunt Zella built a new house on a small acreage north of Brumley and began gardening as if they were trying to forestall a world famine. Uncle Bill's catch of fish would have prevented a lot of hunger, too.

I remember one Thanksgiving dinner with Uncle Bill and Aunt Zella. It was attended by four generations of kin, along with children they helped raise, neighbors they had helped and who had helped them, people they worked with in church, the pastor and former pastors, fishing buddies, fellow gardeners, Lions Club members, mail route patrons, farmers Uncle Bill had traded work with, housewives with whom Aunt Zella had shared kitchen tasks—maybe one hundred fifty people. Maybe more. And not one stranger.

There is not much to see in Brumley anymore, a striking contrast to the nearby Lake of the Ozarks tourist area. Now, buses carry children to a consolidated school. But Brumley still exhibits a strong community spirit.

GEOGRAPHY: A DEFINED VAGUENESS. The geology, history, folklore, and culture of the Ozarks are distinct, but the precise thing that makes the Ozarks unique remains nebulous. Most likely, it has to do with the people who shape the land and are shaped by it.

Most people are as vague about what and where the Ozarks are as they are about its name. There are a number of theories, but the most plausible is that the name evolved from the French, *aux arcs*. *Aux* is a preposition meaning *of, to,* or *from,* while *arcs* signifies *hills* or *bows.* Roughly, the pronunciation of *aux arcs* is *Ozarks*.

Distinct in some places, the boundaries of the region are virtually indistinguishable in others. Just south of Cape Girardeau, Missouri, the hills end where the delta country begins. This abrupt geological division continues southwestward, eventually meeting and following the Black River. At Poplar Bluff, Missouri, and Black Rock, Arkansas, one drives through rolling hills, crosses a bridge, and emerges in flatlands. Downstream from the confluence of the Black and White Rivers, the Ozarks' boundary arcs to the west. Meeting and following the Arkansas River Valley upstream into Oklahoma, the boundary then swings north along the Neosho River, near

the point where it joins the Arkansas. The Ozarks' border then proceeds northeastward, catching just the southeast corner of Kansas and continuing to Boonville, Missouri, on the Missouri River. Then it turns east, approximately following the Missouri to Pacific, Missouri, near the St. Louis, where it cuts across and follows the Mississippi to Cape Girardeau. Some authorities say the region includes two Illinois counties across the river and north of Cape Girardeau. The residents of this area have taken some pride in promoting the "Southern Illinois Ozarks."

In *The Ozarks: Land and Life,* Dr. Milton D. Rafferty, of Southwest Missouri State University at Springfield, calls the Ozarks a parallelogram that includes parts of four states, but not the southern Illinois hills. Rafferty points out that the Ozarks form part of a larger province called the Interior Highlands, which extends the parallelogram some one hundred miles to the southeast, taking in the Arkansas Valley and Ouachita Mountains. Dr. Rafferty also notes that the region is variously called the Ozark Mountains, Ozark Plateau or Plateaus, Ozark Upland, Ozark Highland, and Ozark Hill Country. He prefers upland because it has "a very general meaning." I prefer Ozarks because it is less specific, more magical.

Mountaineers is an apt enough description for the people, but in truth the Ozarks are not very mountainous. The St. Francois Mountains in eastern Missouri and the Bostons and Ouachitas in Arkansas come closest to qualifying as mountains. The igneous rocks of the St. Francois Mountains are not found elsewhere in the Ozarks or Ouachitas. As the overlying sedimentary rocks weather and erode, the once-molten rocks are slowly exposed, along with knobs of granite and felsite. Where streams force through these resistant rocks, rugged gorges called shut-ins appear. In *Geological Wonders and Curiosities of Missouri,* Thomas R. Beveridge wrote, "Intensively fractured igneous rock is commonly exposed in our Ozark shut-ins. This fracturing contributes to the beauty, helping to produce vertical canyon walls and pinnacles as well as a maze of stream patterns with potholes and water-polished, naturally sculpted igneous rocks."

Johnson Shut-ins, fourteen miles southwest of Ironton, Missouri, the best known though not the largest shut-in, has been developed as a state park, as has Millstream Gardens. Stouts Creek Shut-ins, just above Lake Killarney, shares Johnson and Millstream's accessibility. Thirty-seven other accessible and popular shut-ins located in Wayne, Iron, St. Francois, Madison, Washington, and Reynolds Counties are listed in Beveridge's book.

The highest point in Missouri, Taum Sauk Mountain rises 1,772 feet above sea level and is part of the St.

Francois Mountains. Nearby is cone-shaped Pilot Knob. The Taum Sauk Trail leads hikers to Mina Sauk Falls (which cascade 132 feet), Devils Toll Gate (an eight-foot-wide, thirty-foot-high and fifty-foot-long opening in reddish igneous rock), Johnson Shut-ins, and Elephant Rocks (a herd of pink boulders near Graniteville).

While the St. Francois Mountains hold many geological wonders and curiosities, the Boston Mountains are higher and are truer to the Ozark landscape. Elevations of more than two thousand feet are found over much of Madison, Washington, Franklin, Johnson, Pope, and Newton Counties in Arkansas. The Boston Mountains are a relatively smooth, though far from flat, plateau surface. South of Jasper, Highway 7 follows a high ridge overlooking the broad Limestone Valley, which lies more than one thousand feet below. The Richwoods Basin in Stone County is a similar pocket of agricultural prosperity, and there are lesser basins throughout the Bostons. South of Fayetteville, U.S. 71 follows a high, broad ridge affording a vista of broad valleys.

Cutting through the Boston Mountains is the Buffalo River, flowing to its confluence with the White River that skirts the Bostons to the northeast. Many of the more spectacular geological formations of the Bostons lie in the watershed of the Buffalo: Hemmed-in Hollow, Big Bluff, Lost Valley, and numerous caves, natural bridges, waterfalls, and spectacular bluffs.

In addition to the St. Francois and Boston Mountains, Dr. Rafferty lists seven other geographical regions within the Ozarks: the White River Hills along the Arkansas-Missouri border; the Springfield Plain, mostly west and south of Springfield, Missouri; the Central Plateau, a large slice running east to west through the middle of the region; the Osage-Gasconade Hills, including a large portion of the watersheds of those two rivers and Lake of the Ozarks; the Courtois Hills, west and south of the St. Francois Mountains, including the watersheds of the Current and Eleven Point Rivers; the Missouri River Border; and the Mississippi River Border.

To complicate things further, there are areas identified in the vernacular. "Cherokee County" and the "Cookson Hills" of northeast Oklahoma and the "Tri-State District" around Joplin, Missouri, are all on the Springfield Plain. The "Shepherd of the Hills Country" and "White River Country" are in the White River Hills. Both the "Missouri Rhineland" and "Boonslick Region" lie in the Missouri River Border. The "River Hills Region" falls within the Mississippi River Border. the "Tiff Belt," "Lead Belt," and "New Lead Belt" are parts of the St. Francois Mountains. The "Irish Wilderness" is in the steep, wild Courtois Hills.

▲ Reflections of fall foliage add color to the Black River at Johnson Shut-ins. The river's East Fork is constricted in width and steepened where it cuts through the resistant igneous rock. One of the favorite natural attractions in the Ozarks, the Johnson Shut-ins State Park is situated fourteen miles southwest of Ironton, Missouri.

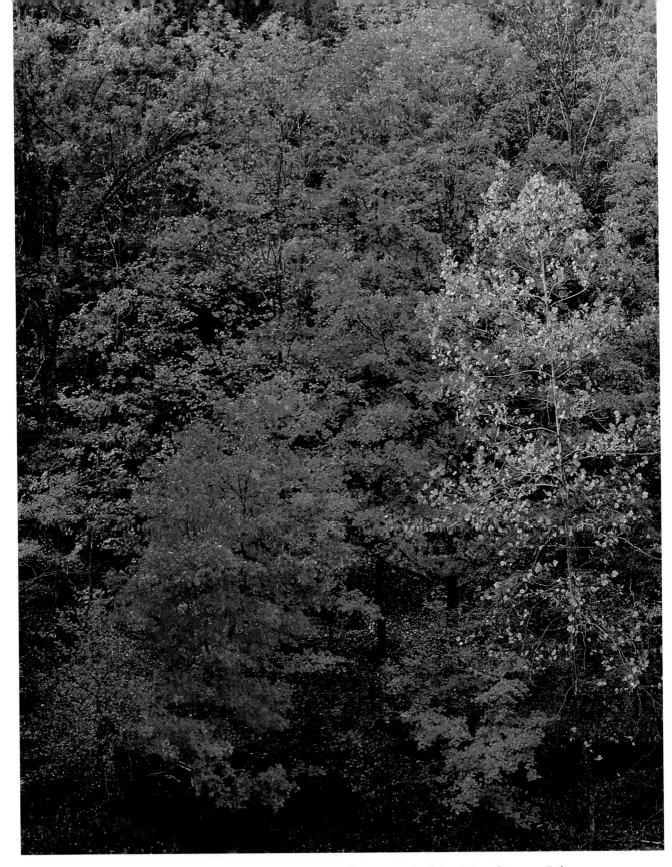

▲ Known as the "Flaming Fall Revue" or the "Festival of the Painted Leaves," the autumn coloring of hardwood trees is much anticipated. Predicting how and when the leaves will turn color is tricky, as oaks, hickories, and sycamores present a variety of hues. Yellows and oranges predominate in this grove near Spavinaw, Oklahoma.

This is the Ozarks, some sixty thousand square miles in all. Through my layman's eyes, only the St. Francois Mountains and parts of the Springfield Plain are quickly distinguishable. But whether the terrain is gently rolling or steep and rugged, it presents an endless variety of springs, caves, sinkholes, bluffs, glades, forests of oak and other hardwoods, cedars and pines, clear-flowing streams, and—through man's intervention—large lakes.

The Ozarks are not particularly high in elevation. An understanding of the land is aided by the word "plateau." Picking out the higher points in all directions, one can imagine that all of these points were once part of a fairly level plateau. Countless rains and snows fell, gradually cutting away portions of the soil and the underlying sedimentary rocks, which are limestone, dolomite, and chert. The waters, which penetrated the surface through faults and fissures, carved underground streams and—aided by naturally formed acids—caves of all sizes.

Over the eons, the erosion—both above and below the surface—changed the plateau into a region of hills and valleys of widely varying size, with networks of brooks, creeks, and rivers flowing off to the north, east and south into the Missouri, Mississippi, and Arkansas Rivers. Today, these hills and hollows are heavily forested. The predominant hardwoods are oak, hickory, ash, elm, and black walnut, along with other varieties. Either cedar or pine—both seldom thrive in the same locale at the same time—intermingle in the woodlands.

The Ozarks Plateau and the adjoining Arkansas Valley and Ouachita Mountains—or the Interior Highlands as the combined region is called—are almost surrounded by plains. To the west are the Osage Plains of Missouri, Kansas, Oklahoma, and Texas; to the north, the Till Plains of Missouri and Illinois; to the east, the Mississippi Alluvial Plain of southeast Missouri and eastern Arkansas; and to the south, the West Gulf Coastal Plain of southern Arkansas and Oklahoma. Only by that little range of hills called the Illinois Ozarks do the Ozarks link with other uplands. In fact, those hills of extreme southern Illinois—sometimes called the Shawneetown—may just as properly be considered part of the low limestone plateau to their east in Kentucky, Tennessee, and Indiana.

EARLY SETTLERS. Ties to the hills of Kentucky and Tennessee and the Appalachians farther east are more than geographical. Many early Ozark settlers came from eastern Kentucky and Tennessee, Virginia, and North Carolina. The earliest white Ozark settlements began along the Mississippi and Missouri Rivers one hundred years before settlement in the interior. Marquette and Joliet had explored the Mississippi in 1673, and in 1682 La Salle claimed the Mississippi Valley (and the Ozarks) for France. The French ceded the Province of Louisiana to Spain in 1762, took it back in 1800, and sold it to the United States in 1803.

The salt, lead, and fur trades attracted the French. The earliest French settlements spread from Kaskaskia, established in 1699 on the Illinois side of the Mississippi, across from St. Genevieve, which was established in 1735. Interest in the salt springs to the south and the lead ore in the St. Francois Mountains to the west spurred these settlements, as well as Mine La Motte, established in 1723; Bonne Terre, in 1724; and Old Mines, in 1725. The French also built Fort Orleans on the Missouri near the Ozarks in 1722. Down the Mississippi, Cape Girardeau began in 1793 during the Spanish period, as did Potosi in 1798, and Jackson in 1799.

The French, and later the Spanish, sent expeditions into the interior of the Ozarks seeking gold and silver. Inevitably, some mines were salted with silver, and the legend of silver mines in the region's folklore continues to this day. The French also explored the southern reaches of the Ozarks: Marquette and Joliet reached the mouth of the Arkansas River in 1673; La Salle visited the village of the Quapaws near present-day Little Rock in 1682; and one of La Salle's lieutenants, searching for his missing leader, founded Arkansas Post near the confluence of the White and Arkansas Rivers in 1686.

By 1800, the American frontier has pushed to the extreme eastern edge of the Ozarks, but the main thrust of western migration went around the region. Batesville, Arkansas, on the White River at the southern edge of the Ozarks, was founded in 1812. Greenville, Missouri, fifty miles west of Cape Girardeau on the St. Francis River was founded in 1819, but Van Buren, twenty-five miles farther west on the Current River, was not begun until 1859.

The Ozark interior was forbidding. Warsaw, Missouri, which lies on the Osage River near the western edge of the Ozarks, had its inception in 1826, but Springfield, Missouri, which was to become the Ozarks' largest city and its most important trading center, was not founded until 1830. Fort Smith, a military post at the confluence of the Arkansas and Poteau Rivers, was built to protect travelers and to control Indians in 1817, but Fayetteville, fifty miles north, did not see its beginning until 1836.

There is evidence that several ancient civilizations lived in the Ozarks, but in 1800, when the white man's western migration was poised on the Mississippi, the Osage dominated the vast, rugged territory stretching from the Missouri on the north to Arkansas on the south

and west to the plains. Some of North America's most warlike Indians, they raided white settlements and fought on numerous occasions with other tribes.

Although Osage claims to most of the Ozarks were relinquished in a treaty in 1808, the tribe contended it had given up only land, not hunting rights. Its forays led it into conflict with the Kickapoos, Cherokees, Piankashaws, Shawnees, Weas, Peorias, and Delawares, who had given up lands east of the Mississippi for former Osage lands.

The Osage had an economy based on hunting, gathering, and farming—with an emphasis on hunting. Their system was well suited to the Ozarks, and it is interesting to note that the settlers who supplanted them had a somewhat similar economy, with their emphasis on farming. That emphasis, plus the white man's tendency to overpopulate the fragile land, was to be his undoing.

Years after establishment of settlements on the Ozarks' perimeter, the interior remained dangerous. Henry Rowe Schoolcraft, who provided the first studious report on an unknown portion of the Louisiana Purchase, wrote in his *Journal of a Tour into the Interior of Missouri and Arkansas* in 1818 and 1819 that few approved of his journey at the outset, considering it "very hazardous." Leaving Potosi, he followed the Osage Trace and explored the valleys of the Merrimack and Current Rivers. He may have been the first white man to set eyes on Mammoth Spring. He visited settlements on Sugar Loaf Prairie and Beaver Creek, followed the Osage Trace up Swan Creek, crossed over to the James River, and descended the White by canoe before returning to Potosi. Schoolcraft visited with widely scattered settlers and hunters; crossed paths with Indians; encountered wolves and buffalo; hunted deer, bear, turkey, and wild honey; ate acorns, pumpkin, boiled buffalo bones, and beaver tail; and made copious notes on the terrain, rocks, fauna, and flora.

The geography and geology of the region are easily recognizable today from Schoolcraft's descriptions, but the hardships he endured can only be imagined. The buffalo, wolves, and panthers exist no longer, and turkey and bear survive only because of restocking programs. His descriptions of the forests remain accurate, save for the replacement of virgin hardwoods and pines with smaller specimens. He describes vaster grasslands than one can imagine and makes no mention of red cedars, which have spread widely through the Ozarks, thriving on abandoned homesteads.

Schoolcraft wrote, "I begin my tour where other travelers have ended theirs," but within ten years a wave of migration was filtering into the remote hills and hollows of the Ozarks. It was a special breed of people who chose the Ozarks when more promising lands lay to the north, west, and south. Those who came selected lands close to rivers, creeks, and springs, for they had chosen a life that demanded self-sufficiency.

Russell Gerlach's *Immigrants in the Ozarks* reveals the pattern of settlement in the Missouri Ozarks. In 1830, only the Missouri and Mississippi River border sections had population densities of two to six people per square mile. The southwestern quarter of the state was almost uninhabited. The next push was along the western edge of the Ozarks into the Springfield Plain, leaving only a large bulge at the Arkansas line without significant population. By 1850, the empty area was beginning to disappear, and areas to the west, north, and east were showing considerable growth. In the census of 1860, all parts of the Ozarks showed some population, and Gerlach notes the "dominance of Tennessee stock over much of the rougher and less productive Ozarks, while Kentucky and Virginia stock dominated the more productive Ozark borders." Many of these Tennessee settlers were descendants of North Carolinians who followed a similar pattern in search of available lands.

The settling of the Ozarks continued throughout the nineteenth century. There were large German settlements within the Mississippi and Missouri borders and smaller pockets of Germans on the Springfield Plain. French, Swedish, Polish, Moravian, Austrian, Swiss, Dutch, and other ethnic groups settled in certain communities whose locations were determined by early railroad construction, particularly the Springfield-St. Louis route.

The Civil War impeded settlement of the Ozarks. Although Missouri had been admitted to the Union as a slave state, there was little interest in slavery in a region where only a tiny fraction of the land made it economically attractive. Still, the Ozarks was divided on all other issues attending the war, and the region was contested in two major battles, Wilson's Creek in Missouri and Pea Ridge in Arkansas, and in many lesser battles and skirmishes. Preyed upon by bushwhackers, deserters, renegades, and guerrillas, the Ozarks was a no-man's-land during the conflict. Few buildings survived the war, and bitterness continued in its aftermath as vigilante groups sought to impose law and order.

For the most part, the people of the Ozarks were just concerned with getting by. They built homes from logs, heated them with wood, and raised livestock, gardens, and sometimes cotton or tobacco as cash crops. They also gathered nuts and berries from the wilds and herbs for homemade medicines, hunted wild game for food, and trapped furbearers as another source of cash. They

▲ Cob Cave affords a stunning view of the lower part of Eden Falls, as Clark Creek follows its imaginative path through the Lost Valley in Newton County, Arkansas, to its confluence with the Buffalo River. As evidenced by the small corncobs that have been found there, Cob Cave once provided shelter for Native Americans.

▲ Spring flowers surround a deserted home in the Buffalo River Valley. Bluffs along the one-hundred-fifty-mile-long Buffalo National River provide fine views. Still visible in various parts of the Ozarks, numerous old cabins such as this provide a glimpse into the lives of those pioneers who once inhabited these rugged hills and valleys.

provided their own entertainment and followed the customs, traditions, and religions they brought with them.

Taney County, Missouri, south of Springfield on the Arkansas border, was organized in 1837, but land for homesteading was still available in 1890. In the 1890s, Riley Adams became the first teacher in the Kentucky Hollow log school, with its puncheon floor and split-log seats. Later, a frame building replaced that school. At times, the enrollment reached one hundred, but the school burned and all that remains is the outline of the rock foundation and the rusting remains of the building's last metal roof. A path, nearly overgrown, leads down to the creek and a little rock-solid springhouse. The spring still delivers a clear flow of water, just as it did when it quenched the thirst of those long-departed students. The names and dates written on the springhouse door record the families that emigrated from eastern Kentucky to a remote little hollow in the Ozarks: Combs, Johnson, Albright, David, Horner, Martin, and numerous Blairs. Penned on the front of the springhouse is this statement: "Luther Blair was born here September 19, 1891 to Lewis and Susan Blair."

I remember going to Kentucky Hollow with Bill Blair to see the log cabin where he had lived as a boy more than forty years ago. Of all the log cabins, which together sent nearly one hundred children to the Kentucky Hollow School, it was the only one still visible. On my second visit, its roof had fallen into disrepair. Once the elements are allowed to enter, these sturdy old cabins quickly disintegrate, if the once-prevalent woods fires have not already ravaged them.

Heading down the creek, I wondered at the scant evidence of a once-vibrant community: three homes, a springhouse, the rotting log cabin, the rubble of the old school, and the narrow little bottom along the timeless creek, flanked by steep, wooded hillsides. I forded the creek twice on low-water bridges, and then I was back at the highway. The stream continues across the bottomlands to its union with Beaver Creek, perhaps a mile farther. Nearby, I once attended a baptizing service at a spot on Beaver Creek. It was a joyous occasion, as several small churches initiated those who had accepted Jesus Christ by immersing them in the clear waters.

Then the question I had failed to ask on my previous visits to Kentucky Hollow hit me. I headed back toward Bradleyville to find Bill Blair. I found Blair in "Billy Jack's Pkg. Store & Chain Saw Repair."

"So you've been back to Kain-Tuck Holler," he said. "I ain't been back since I took you thet time. Yeah, I heared the old house was falling down."

Bill was wrestling a big chain saw with a collapsed fuel line. "Shore, there's a cemetery in Kain-Tuck Holler. Hit's on the other road."

I had explored the only road I knew all the way to its end, but another, farther down the highway, leads into the upper stretches of the hollow. There I found the burying ground, overgrown with greenbriers, grapevines, briers, and small trees that had reclaimed that spot since the last cemetery working. Presumably, that was sometime around the last burial: Elnora Mannon died July 7, 1972, at the age of 74 years 7 months 27 days, and Thea Mannon died three years earlier at the age of 94. Other recognizable death dates retreated rapidly back into Kentucky Hollow's heyday: 1948, 1936, 1922, 1911, 1901. A number of stones no longer bore dates—if they ever had—being merely creek-smoothed rocks chosen for their appropriate size and shape to mark the final resting place of a loved one.

This meager evidence of a once-thriving community is supplemented by the memories of people like Emmett Adams, who had written of Kentucky Hollow's people. Self-sufficiency was the order of the day, and there were even those who pulled teeth, although Adams hesitated to call them dentists. The people lived on farms and produced practically all their own food and much of their own clothing, except for shoes.

The pattern by which Kentucky Hollow was settled was set in eastern Kentucky, and before that, in Virginia and North Carolina. Those attracted by free or cheap land and willing to wrest a living from rocky hills tilled a few acres, raised livestock and poultry, gardened, worked in the woods, hunted, and got by. With few exceptions, they raised large families. When the supply of available land grew short in Virginia, there were plenty of immigrants to Kentucky and, subsequently, to the Ozarks. In Kentucky Hollow, the pattern was broken. The frontier had already passed the Ozarks, and no more eighty-acre, or even forty-acre, tracts were available. In a generation or two, Kentucky Hollow's prosperity was past, and with no new land to settle, most people dispersed through the country and into vastly diverse life-styles.

But not entirely. Early settlers of Kentucky Hollow would probably still be at home around Bradleyville, for people there still raise cattle and gardens and work in sawmills or in the timber, albeit with chain saws, not crosscuts. They are good neighbors. They follow many of the old customs and traditions, and their speech patterns are familiar at Billy Jack's, where they step in to get a saw repaired or to purchase beverages that used to be brewed at home or distilled in the backwoods.

OZARK ATTRACTIONS. The eastern end of Taney County is quite a different story. Tourism received its first impetus early in the twentieth century when Harold Bell Wright's novel, *The Shepherd of the Hills,* was published and the first railroad opened up the White River Valley. While the train brought a trickle of visitors, a series of other factors has turned the trickle into a torrent.

With the completion of Powersite Dam on the White River, Lake Taneycomo, the first of the Ozarks' man-made lakes, brought vacationers and fishermen to Rockaway Beach, Forsyth, and Branson. The School of the Ozarks, founded at Forsyth and later moved to Point Lookout, near Branson, filled a void by providing a high school education for students from isolated communities and by allowing the students to pay for their education by working. When needs changed, the school became a junior college. Today, it is a four-year college that still adheres to the earn-as-you-learn concept. In 1952, Bull Shoals Lake, a project of the U.S. Army Corps of Engineers, impounded eighty miles of the Old White River downstream from Powersite. Table Rock Dam, also a Corps project, created another impoundment just above the headwaters of Lake Taneycomo.

There were three lakes and an imaginative college that had a nationwide following of supporters, but it remained for the families of two men to make the greatest impact on the area. Dr. Bruce Trimble purchased the old homestead that was the setting of *The Shepherd of the Hills,* and Hugo Herschend leased nearby Marvel Cave. Both men died before their dreams could come to fruition, but their widows, both named Mary and both now deceased, proved to be the stuff of which legends are made. Mary Herschend and her sons, Jack and Peter, developed the 1880s-style Silver Dollar City, an entertainment complex featuring arts, crafts, music, and theme park rides above Marvel Cave. Today, Silver Dollar City hosts two large craft festivals, a music festival, and almost 1.5 million customers each year. Mary Trimble and her son, Mark, made Shepherd of the Hills Farm a tourist mecca of similar magnitude and the site of the largest outdoor drama in America, where a quarter of a million people see Wright's story reenacted each year.

Out of these developments rose another phenomenon. The Baldknobbers, a homespun country music show featuring four Mabe brothers, struggled for an audience in an old building on Branson's lakefront for several years. Then another Ozark musical family, that of Lloyd Presley, built Mountain Music Theatre on the highway leading from Branson to Shepherd of the Hills Farm and Silver Dollar City, and the Baldknobbers soon followed suit.

Drawn by the lakes, by Silver Dollar City, by Shepherd of the Hills Farm, and by other attractions, the crowds made the new music shows an almost instant success.

Today, there are numerous shows, mainly featuring country music and lowbrow comedy styled to family audiences. Encompassing a swatch of the Ozarks from Springfield, Missouri, to the Arkansas line and centered on Branson—especially its "Strip"—and Silver Dollar City. "Ozark Mountain Country" has a growing number of entertainment show seats and lodging and camping units. Add to this a plethora of restaurants, snack shops, gift shops, and other amusements and attractions.

A startling contrast to nearby communities such as Bradleyville, where the old way of life seems largely undisturbed, this intensely developed tourist area is an anathema to many environmentalists and conservationists. But it is a boon to employment and economic development, and the values of the old Ozarks are alive in the glitter of the Branson "Strip."

Peter Engler, proprietor of a popular Branson shop, and his late mother, Ida Engler, nurtured Ozark woodcarving. As a result, hundreds of Ozarks people earn all or part of their living from wood sculpture or carving. Bob Mabe, who left the country music show he founded with his brothers to start his own Bob-O-Links Country Music Hoe-Down, is acutely aware of his roots. People like Lloyd and Mollie Heller helped start the *Shepherd of the Hills* pageant and then launched enterprises providing outlets for performers and craftsmen. During the tourist season, the Mutton Hollow's Mountaineer Book Shop features regional literature. Mutton Hollow is a reconstructed village in the valley below Inspiration Point, where Harold Bell Wright wrote. These institutions offer atmosphere and value that seem in keeping with the Ozark heritage, but the ultimate determiner of success or failure for this welter of enterprise is the buying public.

ARTS AND CRAFTS. When a handweavers' guild held a short course at the home of Lester and Blanche Elliott in 1953, they found the setting idyllic. The beautiful War Eagle River, which coursed through a wide valley covered with pine and hardwood forests and surrounded by hills, fed an old mill pond. The Elliotts' home, its huge pine logs hewn by a pioneer named Sylvanus Blackburn in 1832, was one of very few in the Ozarks that survived the Civil War. The rest of the structure, added through the years, became a lodge and restaurant before the Elliots took up residence.

The original weaving course generated so much enthusiasm that an exhibition was held and other artists and

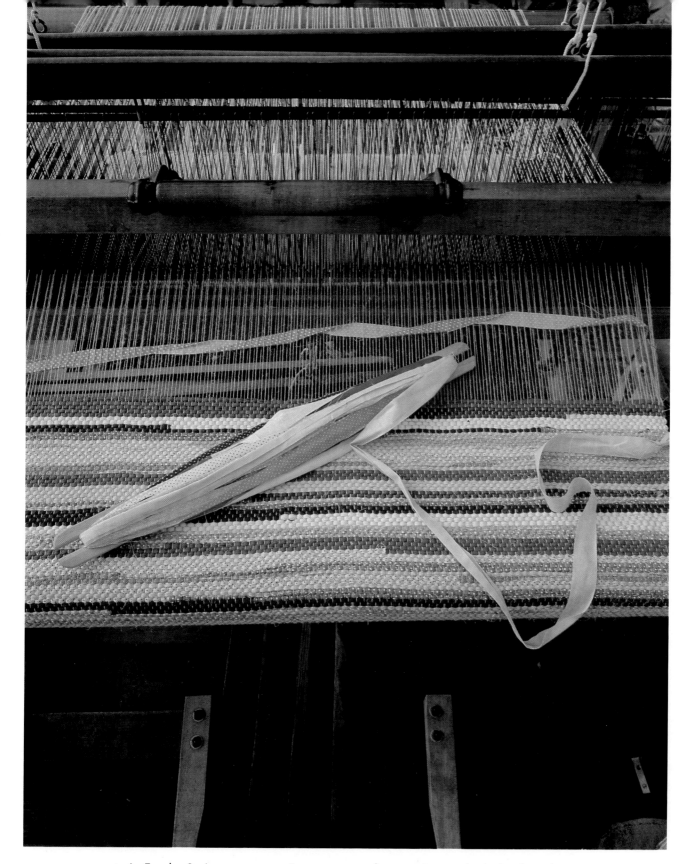

▲ In Eureka Springs, a rag rug is woven on a loom, using methods that have been followed for centuries. Some twenty-five miles to the south is the remote hamlet of War Eagle, where the Northwest Arkansas Handweavers Guild held a workshop and an exhibit in 1953. So was born the War Eagle Fair, held each year in October.

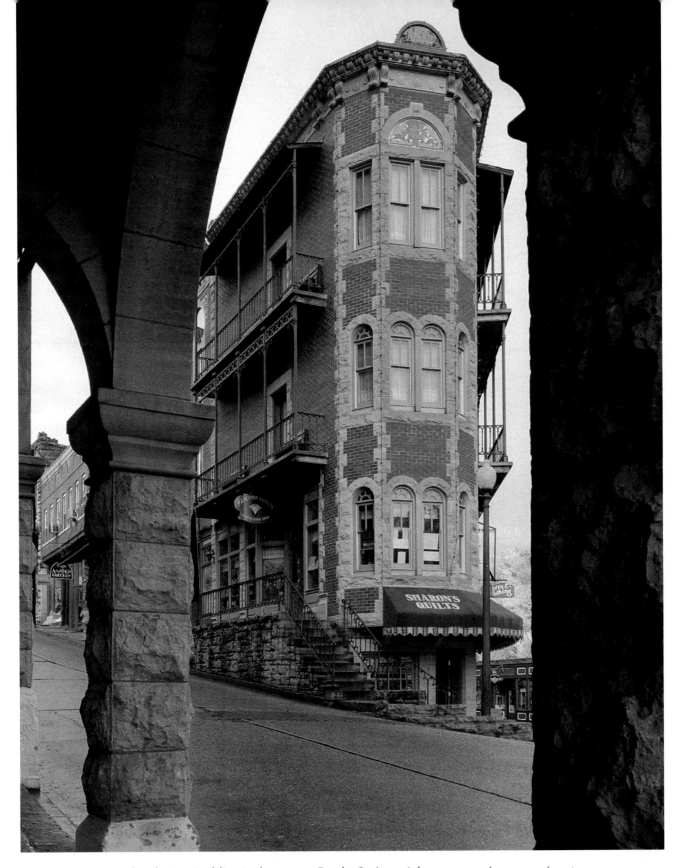

▲ The Flatiron Building in downtown Eureka Springs, Arkansas, remains a prominent landmark and still offers lodging accommodations. In 1880, when the unusually shaped building was constructed, the town boasted a total of two thousand buildings.

craftspeople were invited to show and sell. As the roads to War Eagle consisted of dirt and gravel, and the closest sizeable town was twenty miles away, expectations were not great. But surprisingly, there were three dozen exhibitors and 2,259 guests.

Since then, the War Eagle Fair has been held every year. It has grown to a three-day affair beginning on the third Friday in October with five hundred exhibitors and an estimated one hundred thousand visitors. There is no charge for parking or admission, and cars and people fill the valley to its capacity.

Blanche Elliott, who served as executive director of the fair from its inception and continued well into her eighties, insisted on keeping the fair free to the public and tightly restricted to high-quality arts and crafts from what she called the Ozark states—Arkansas, Kansas, Missouri, and Oklahoma. Commissions and booth fees, paid by exhibitors at the Fall Fair and an Antique and Heritage Craft Show held at the same location the first weekend in May, allow the non-profit Ozarks Arts and Crafts Fair Association to sponsor an annual arts and crafts seminar in mid-June and to contribute to scholarships and historical preservation projects.

The fair's impact is immense. Sales total about half a million dollars, and with every motel and restaurant in northeast Arkansas filled to capacity, the amount of money generated runs rapidly into the millions.

On the same October weekend, a dozen or more arts and crafts events take place in the vicinity. They range in size from yard and parking lot setups to the Bella Vista Arts and Crafts Festival, which rivals War Eagle in every respect. Bella Vista, a retirement development twenty-five miles away, has a well-organized volunteer group that manages the show and operates an arts and crafts shop the rest of the year.

The War Eagle Fair retains historical preeminence, but the five-week-long National Festival of Craftsmen at Silver Dollar City surpasses it in sales. Arts and crafts events occur somewhere in the Ozarks almost every weekend from April into October, and the number of shops featuring arts and crafts of the Ozarks has increased dramatically and is still growing.

The War Eagle Fair provided the impetus for the arts and crafts movement in the Ozarks. The Arkansas-wide Ozark Foothills Craft Guild, based in Mountain View, operates five shops and hosts three important fairs each year. Scores of individuals and organizations such as the Ozark Native Craft Association of Winslow, Arkansas, nourish the movement. They have all derived inspiration from War Eagle.

Folk music has undergone a similar revival in the Ozarks, although the economic impact is far less. There are thousands of people earning all or part of their livelihood from arts and crafts, while only a few hundred gain any income from folk music. But folk music is thriving, thanks largely to the establishment of the Ozark Folk Center at Mountain View, Arkansas, and to such events as the Original Ozark Folk Festival in Eureka Springs, Arkansas, which dates from 1948.

Today, Mountain View's offerings include the Ozark Folk Center, with its regular folk music programs; the Jimmy Driftwood theatre, which features the Rachensack Folklore Society; the Mountain View Folklore Society, which performs on the courthouse lawn in summer and in their own hall in winter; the Grandpa Jones Dinner Theater; and a coffeehouse featuring folk music. Yet not surprisingly, living rooms and porches all over the Ozarks play host to some of the best folk music; and many localities, such as Salem, Arkansas, have regularly scheduled folk music sessions that are free to the public.

Best known for music, the Ozark Folk Center is run by the state of Arkansas and features crafts and folkways. Folk musicians perform at the center and fill other important roles there as well, directing crafts, working as nature guides and beekeepers, and demonstrating pioneer skills.

THE WATERS. After private interests had dammed the White River at Powersite in 1913 and the Osage River at Bagnell in the early 1930s, the U.S. Army Corps of Engineers finished Norfolk Dam and Lake on the North Fork of the White River in 1943, Bull Shoals Dam and Lake in 1952, Table Rock Dam and Lake in 1958, and Beaver Dam and Lake in 1964. Most of the Upper White River was impounded.

In the eastern Missouri Ozarks, two smaller lakes, Wappapello and Clearwater, were created. Also in southwest Missouri, Pomme de Terre Lake, Stockton Lake, and Truman Lake impounded the Pomme de Terre, Sac, and Upper Osage Rivers respectively. In Arkansas, a dam on the Little Red River created Greers Ferry Lake.

The Arkansas River was dammed at Dardanelle in 1965. Eastern Oklahoma acquired the big reservoirs of Grand Lake of the Cherokees, Fort Gibson, and Tenkiller Ferry. And in the southwestern Arkansas Ouachitas, extensive Lake Ouachita near Hot Springs was joined by lesser impoundments such as Lakes Blue Mountain, Nimrod, Maumelle, Hinkle, Wilhelmina, and Hamilton.

With many projects afoot in 1965, conservationists worried the Corps was out to dam every free-flowing stream in the Ozarks. Built with the objectives of flood

▲ Near Gore, Oklahoma, Lake Tenkiller State Park, which includes 12,900 acres and 130 miles of shoreline, appeals both to local residents and to out-of-state visitors. The lake is stocked annually with 96,000 trout, along with black bass, channel catfish, white bass, and crappie. The lake was named for a Cherokee farmer named Tenkiller.

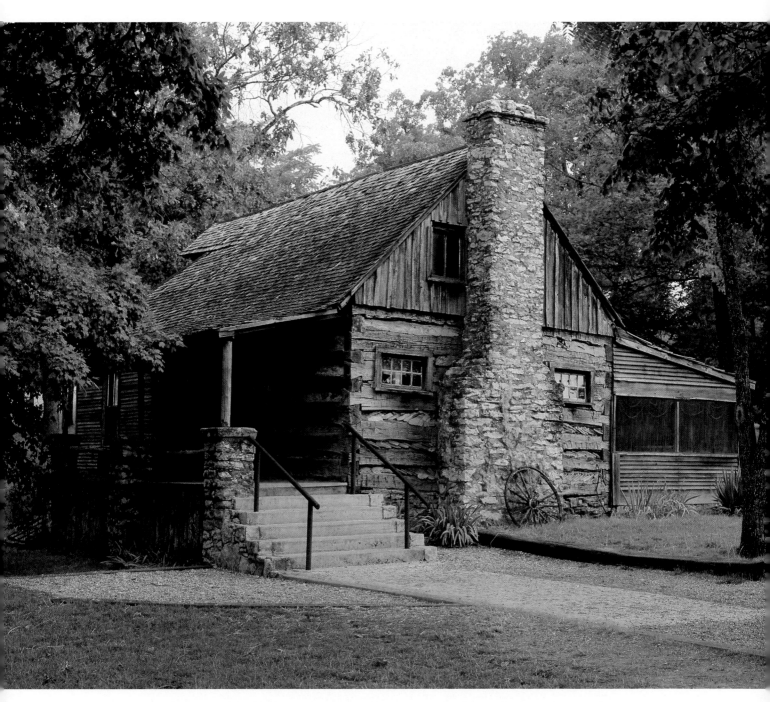

▲ When Harold Bell Wright was writing *The Shepherd of the Hills,* this cabin was the home of Mr. and Mrs. J. K. Ross. After the book was published in 1908, it became known as Old Matt's Cabin. Although the Rosses had moved to nearby Roark Valley, they were identified as Old Matt and Aunt Mollie. ▶ ▶ Autumn spreads a riot of color near the entrance to Ha Ha Tonka State Park in Camden County, Missouri.

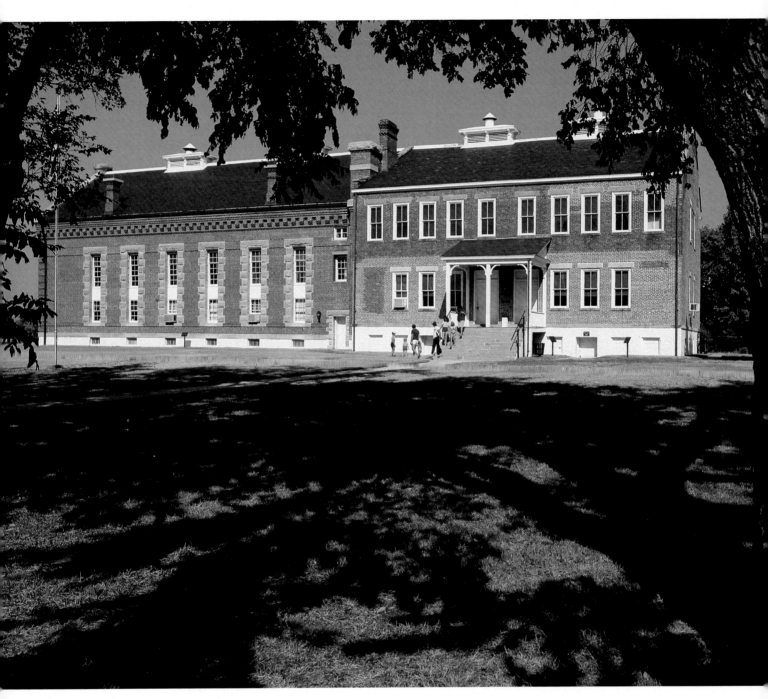

▲ "Hanging Judge" Isaac C. Parker presided over this barracks, courthouse, and jail complex in Fort Smith, Arkansas, from 1875 to 1896, imposing his interpretation of law on the Indian Territory. The courtroom and gallows have been restored.

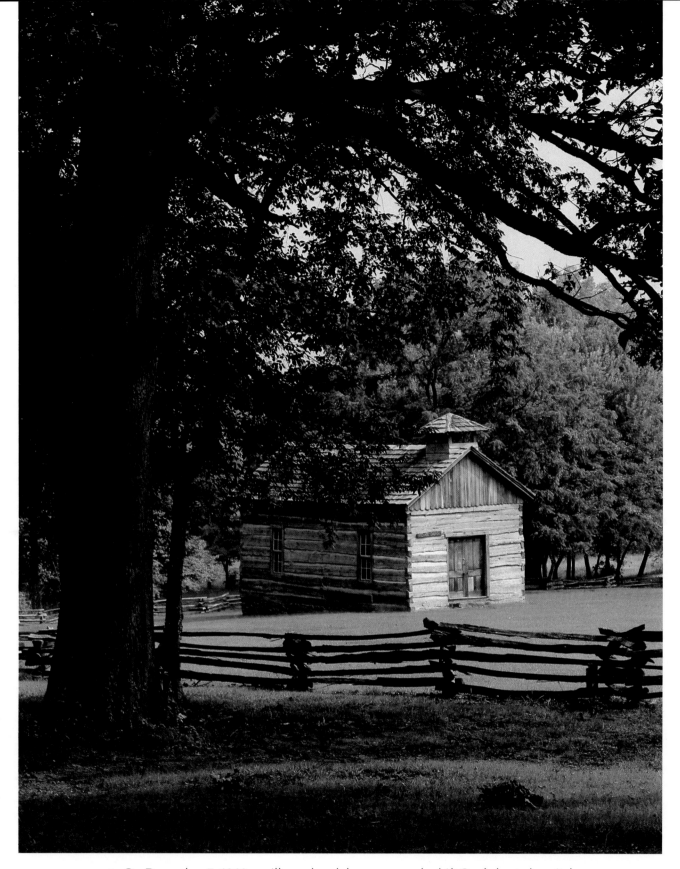

▲ On December 7, 1862, a village church became a makeshift Confederate hospital in the Civil War Battle of Prairie Grove, Arkansas. Out of the approximately ten thousand soldiers from both sides who were engaged in the conflict, the Union lost 1,251; the Confederates lost 1,311. Although there was no clear winner in the conflict, the Confederates withdrew during the night, leaving the field to the Union.

◄ The Jacks Fork River flows near Eminence, Missouri, on its way to its confluence with the Current River. ▲ Sugar Loaf Mountain rises majestically out of the mist above Greers Ferry Lake near the resort and retirement community of Fairfield Bay, Arkansas. The dam near Heber Springs backs up the waters of the Little Red River.

▲ A spring-fed pond furnishes power for the Alley Spring Mill in Shannon County near Eminence, Missouri. ▶ Alley Spring flows an average eighty-one million gallons per day, still powering the turbine of the old red mill, built in 1894. During the summer months, the mill continues to grind corn on buhrstones for demonstrations.

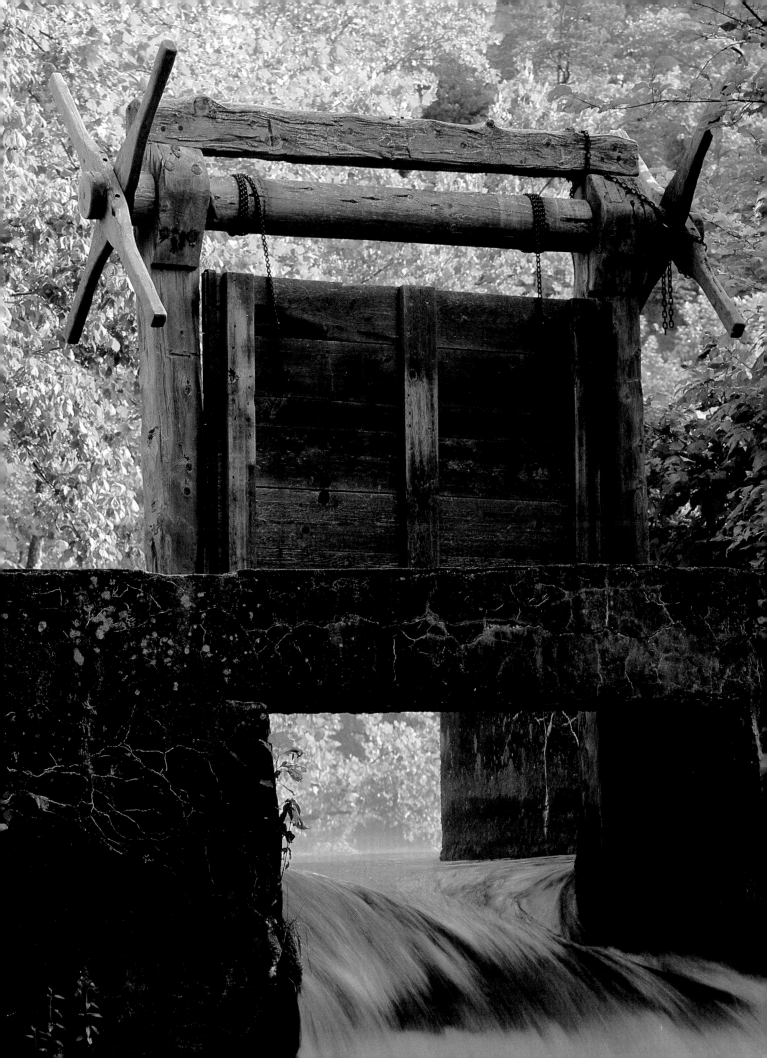

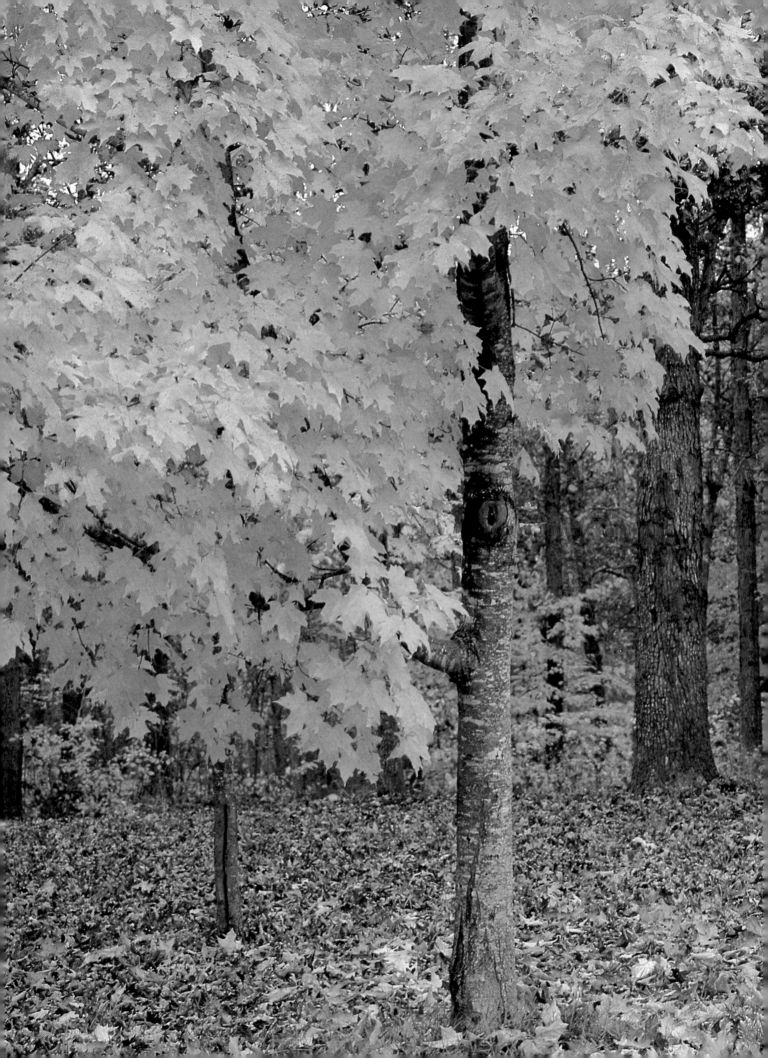

◄ Yellowing maples decorate the forest at Lake of the Ozarks State Park. ▲ Mush-
room hunters in the Ozarks begin foraging for the prized morels in the spring and
may cap a long season with a find of *hygrophorus* as late in the year as November.
"Yellow sweetbreads" are best eaten fresh, but they may be frozen if necessary.

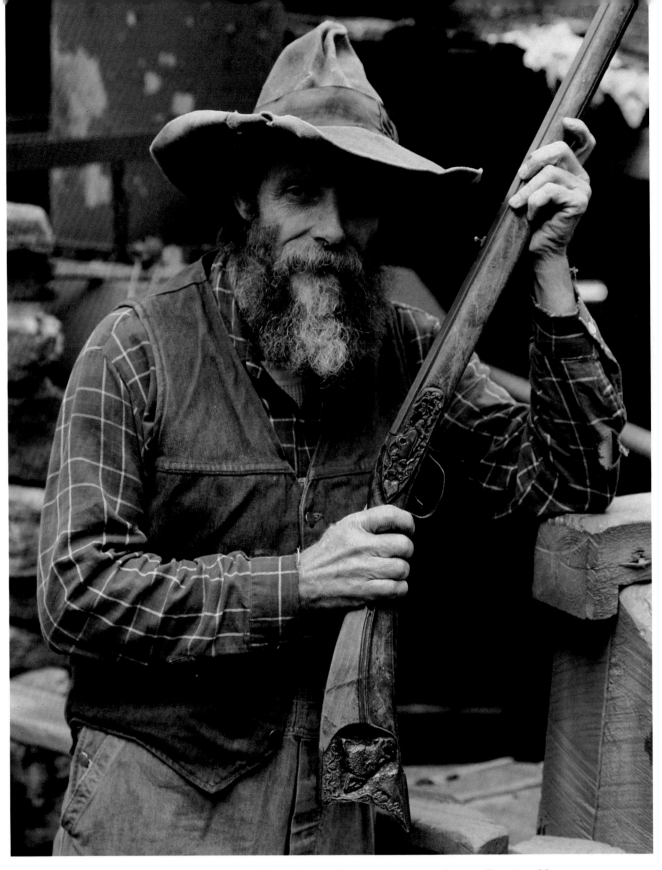

▲ Bruce B. Grimes, a gunsmith in Silver Dollar City, Missouri, shows off a .40 caliber rifle with a hand-carved stock. ▶ At Owl's Bend on the Current River in Missouri, a blacksmith's shop and forge is a cultural demonstration sponsored by the National Park Service. The village has had a blacksmith shop since before the Civil War.

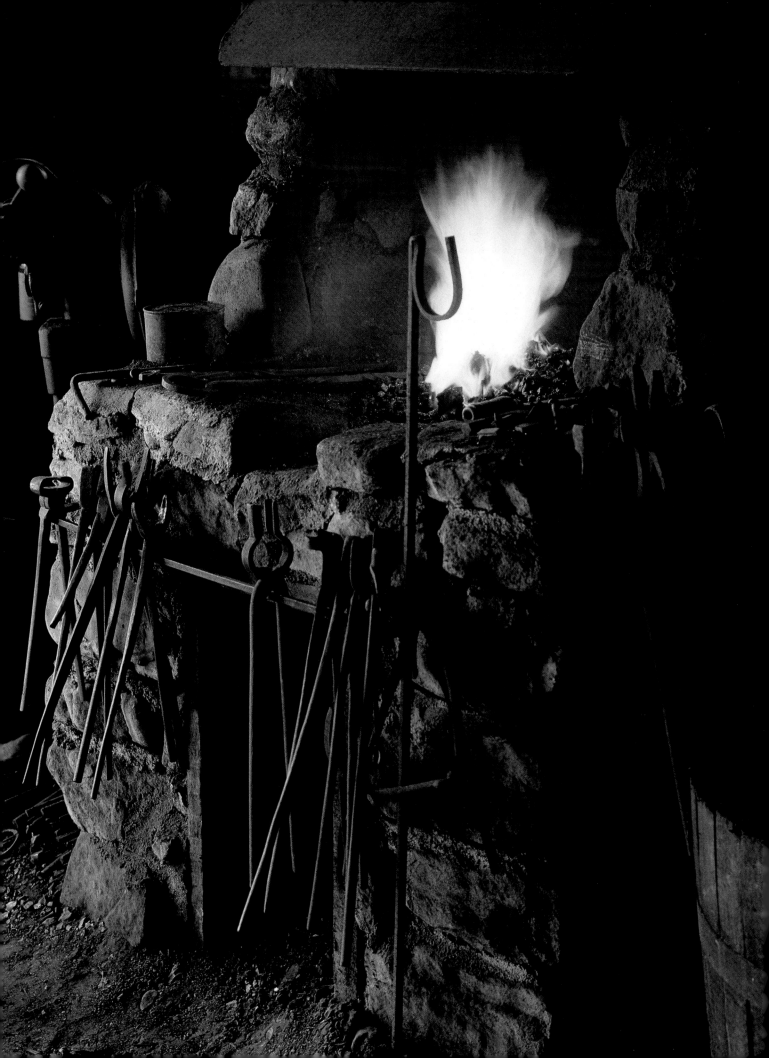

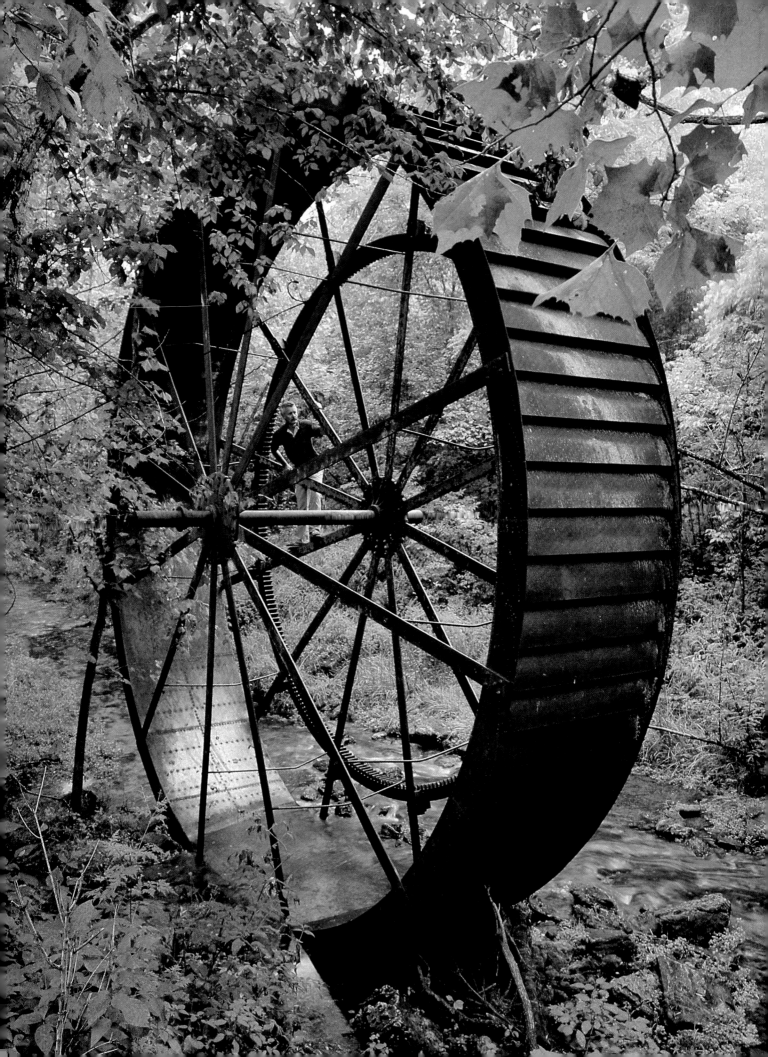

◄ A flume once carried spring water to the huge, overshot wheel of Turners Mill, built before the turn-of-the-century in Oregon County, Missouri. Now the wheel rusts as the waters meander around it en route to the Eleven Point River. ▲ Ancient bluffs of stoic gray peer through a forest of changing colors in this view to the north of White Rock Mountain. Gum trees are crimson; oaks and hickories range from yellow to brown. ► ► White Rock Mountain gives a topside view of the Boston Mountains.

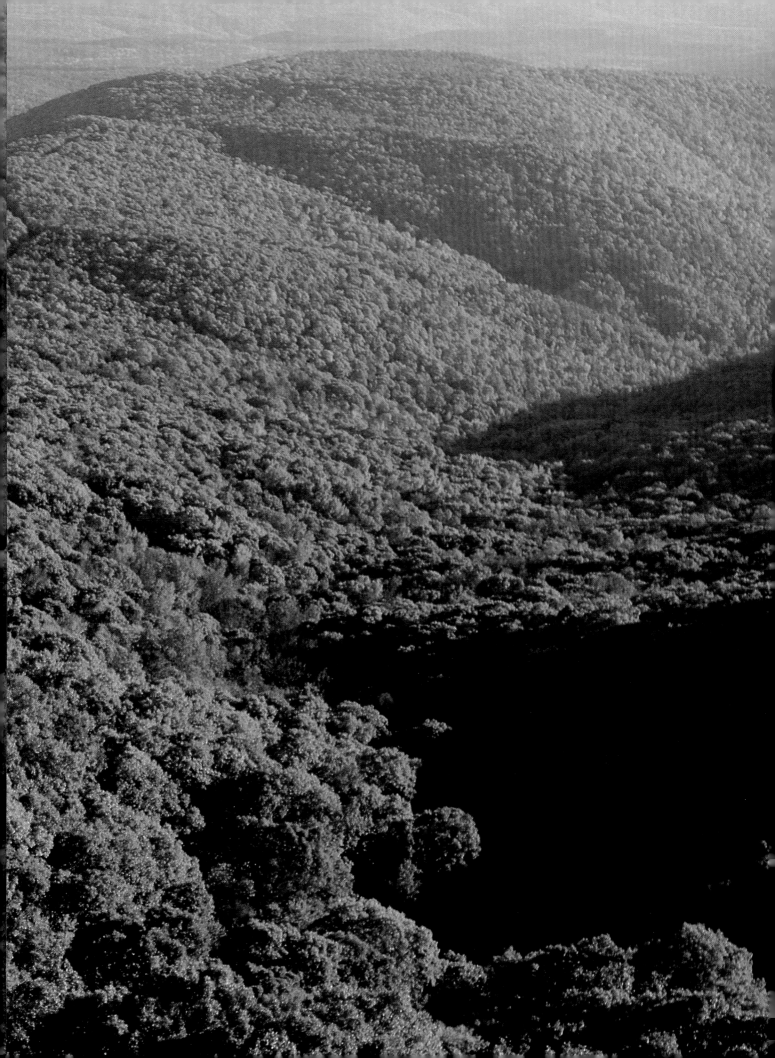

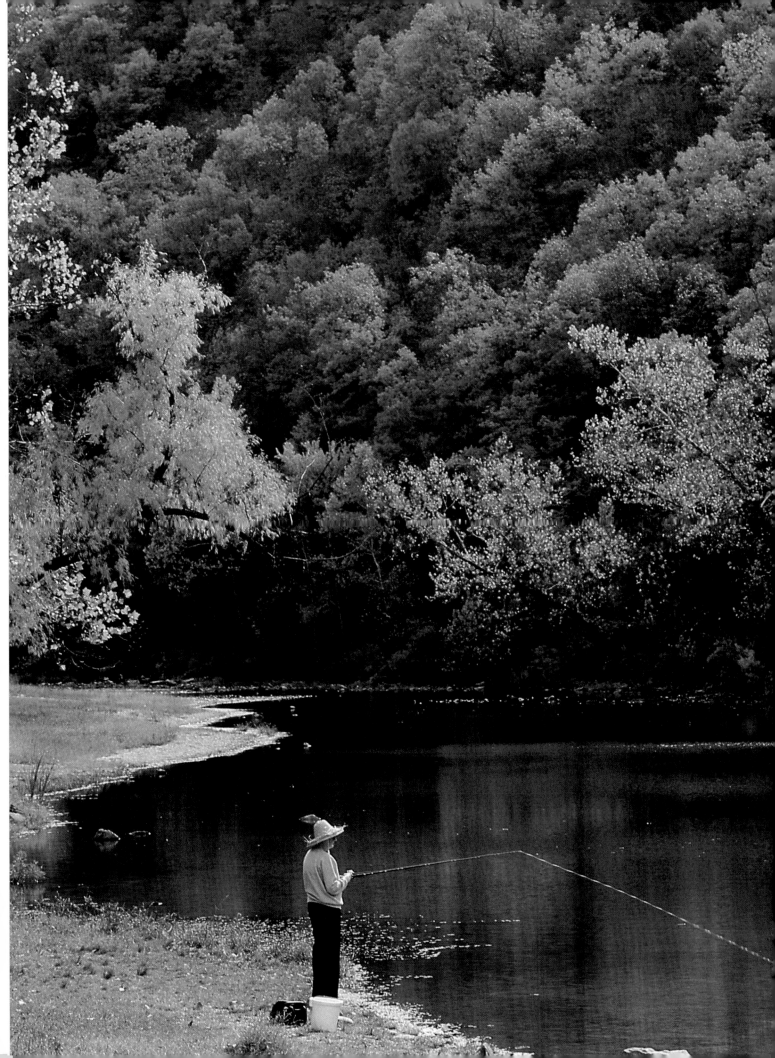

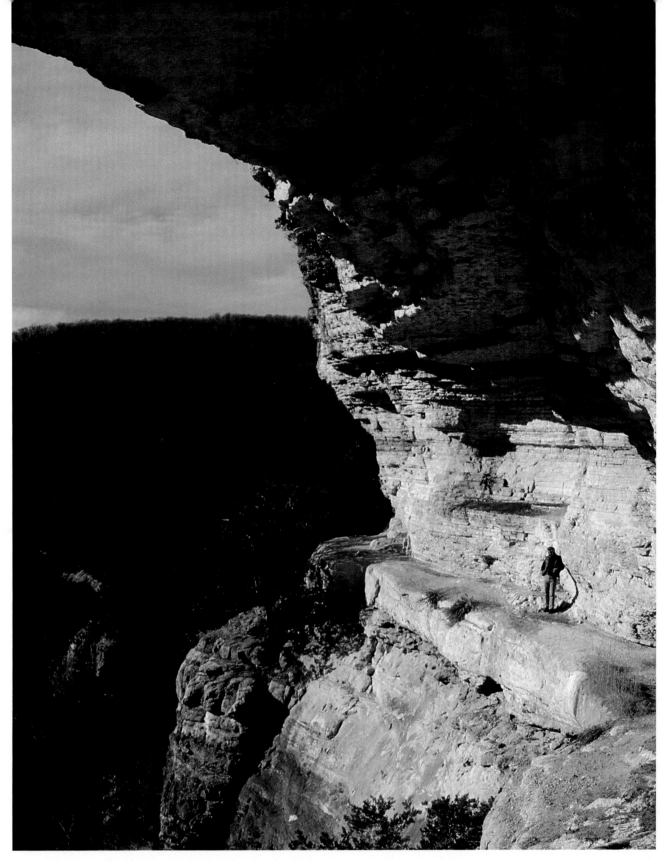

◄ Fishing in the Spavinaw Creek, near Spavinaw, Oklahoma, and in numerous other locations throughout the Ozarks is recreation as well as an aid to the family's diet.
▲ Overhanging bluffs gave shelter to the Ozarks' earliest residents, the Bluff-dwellers.

▲ An average of 276 million gallons of water a day boils out of a jumble of boulders that comprise the wreckage of the orifice of Big Spring in Carter County, Missouri. The water flows only about one thousand feet before joining the Current River.

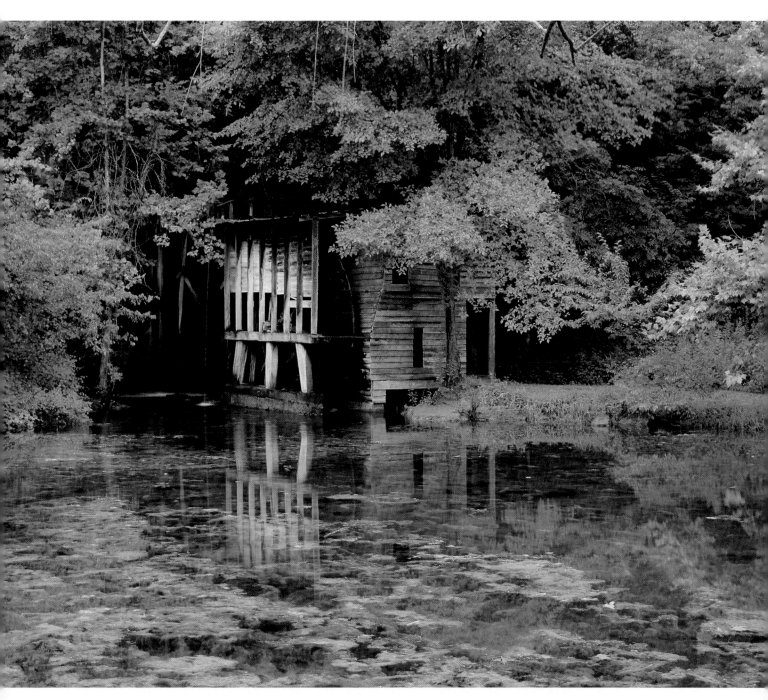

▲ Falling Spring Mill is situated on Hurricane Creek near the Eleven Point River in Missouri. During the last century, most mills had to rely on water to drive their machinery, so the sites of choice were near flowing streams and rivers. The current Falling Spring Mill, which is still operable but not in use, was built in the late 1920s.

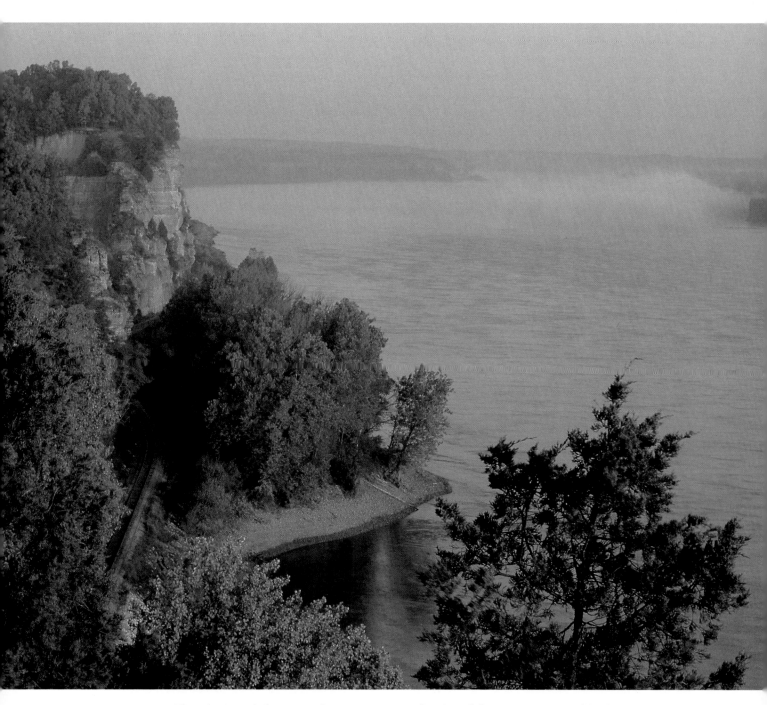

▲ The view north from a rocky promontory—the site of the 1720 outpost of Ensign Girardot, a Frenchman from Kaskaskia—reveals the dramatic bluffs that line this part of the Mississippi River. The permanent settlement of Cape Girardeau, Missouri, came later in the century, long before pioneers settled the interior of the Ozarks.

▲ One of two major Civil War battles in the Ozarks was fought at Pea Ridge, Arkansas, now a national military park. On March 7, 1862, fierce fighting broke out near Pea Ridge for the control of the Trans-Mississippi. The two-day battle brought alternating success for each side, but culminated in victory for the Union forces.

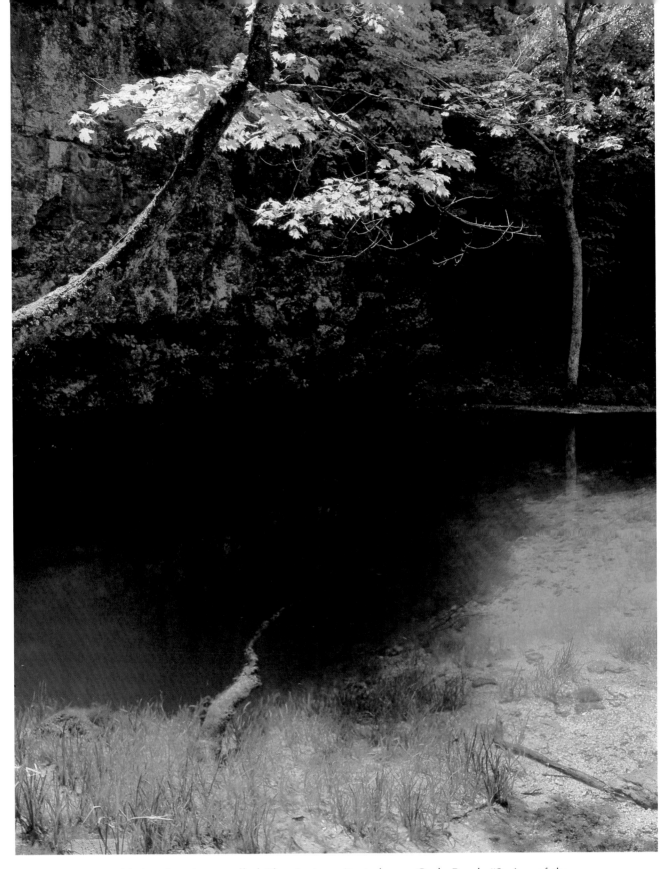

▲ Native Americans called Blue Spring, situated near Owls Bend, "Spring of the Summer Sky." With an average flow of ninety million gallons per day, Blue Spring is the sixth largest of Missouri's springs. It has been explored to a depth of 256 feet.

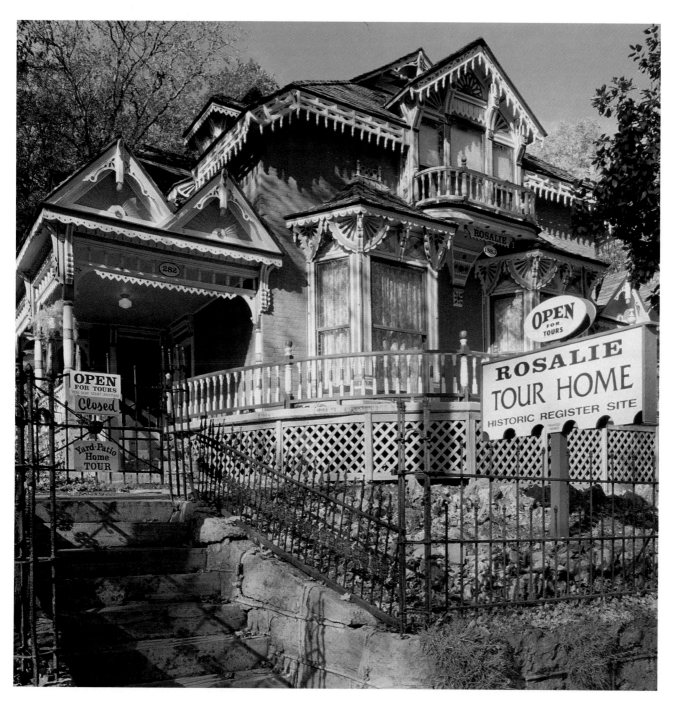

▲ The Rosalie House, constructed in the 1880s in Eureka Springs, Arkansas, has been restored to its original condition. It is furnished with period furniture and accessories. Tours are conducted daily, and weddings take place in the historic house year-round.

▲ Mists hover over cold water and crisp watercress in a branch running from Round Spring into the Current River in Shannon County, Missouri. Part of the Ozark Scenic Riverway, the spring discharges twenty-six million gallons of water on an average day.

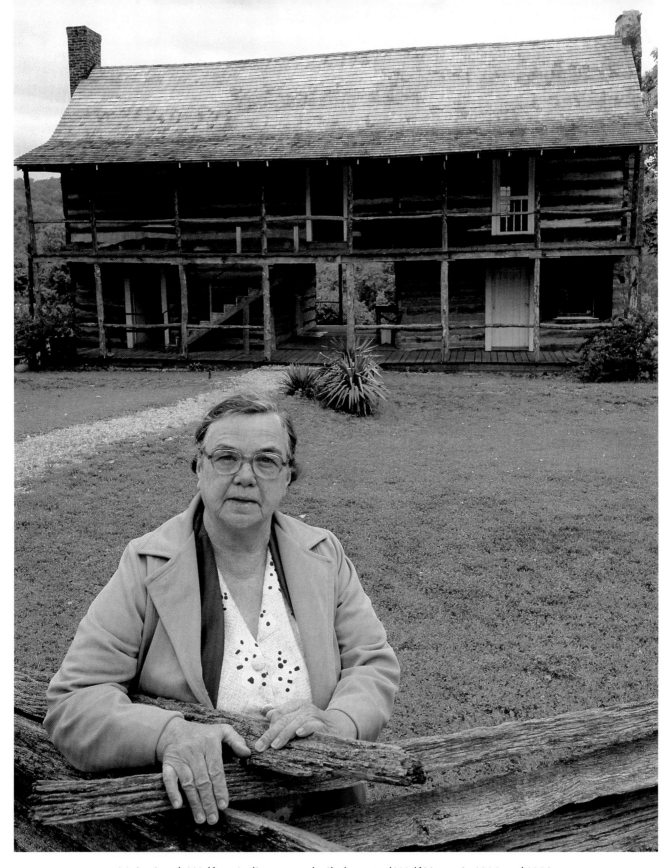

▲ Major Jacob Wolf, an Indian agent, built the grand Wolf House in 1828 and 1829, at the junction of the North Fork and the White River at present-day Norfork, Arkansas. Today, his great-great-grandniece, Helen Chapman, conducts tours of the home.

▲ In Roaring River State Park, Missouri, the spring-fed waters of the river churn a year-round collage of crystal, emerald, and white. The park's liveliest day is March 1, when trout season opens. That day, the park's attendance averages up to twenty thousand.

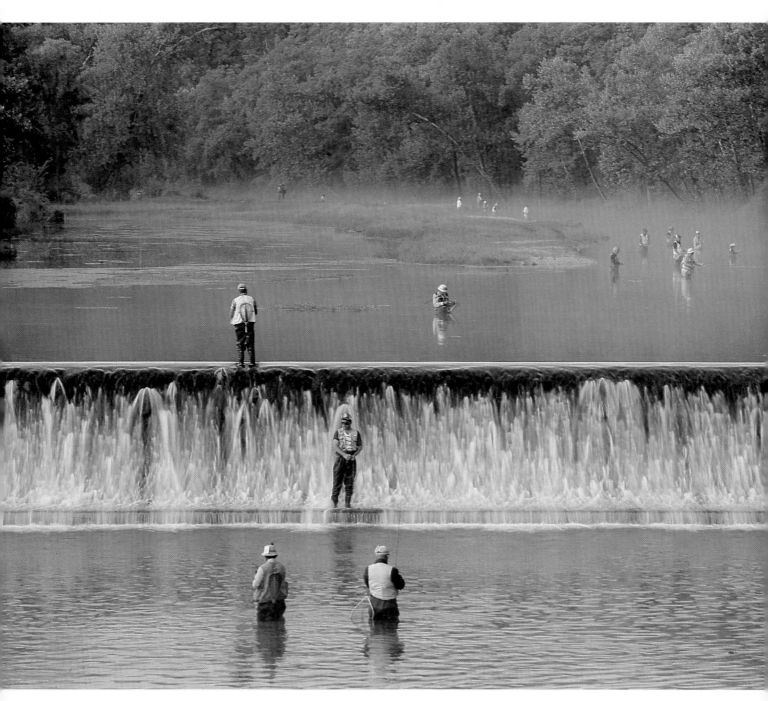

▲ The fourth largest of Missouri's springs and one of the most highly developed, Bennett Springs in Dallas County, west of Lebanon, is a state park that includes a trout hatchery, an old mill dam, and two miles of creek that is popular with trout fishermen. ▶ ▶ Alum Cove Natural Bridge in the Ozark National Forest between Deer and Parthenon, Arkansas, was actually used as a bridge by the early settlers.

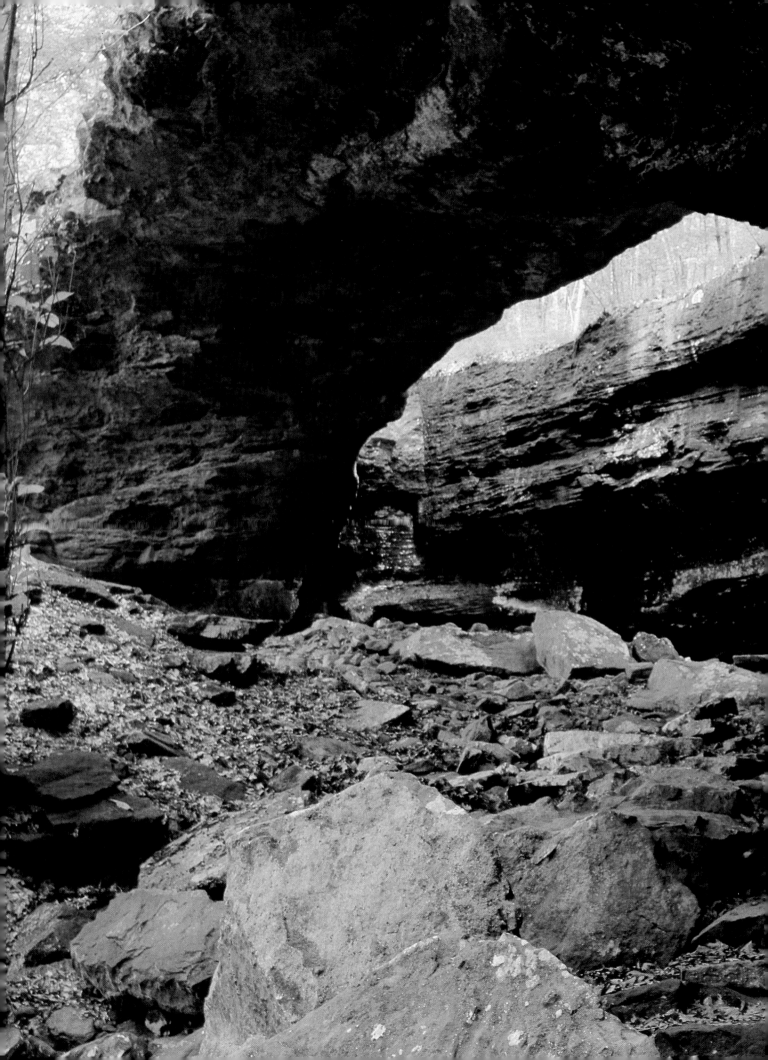

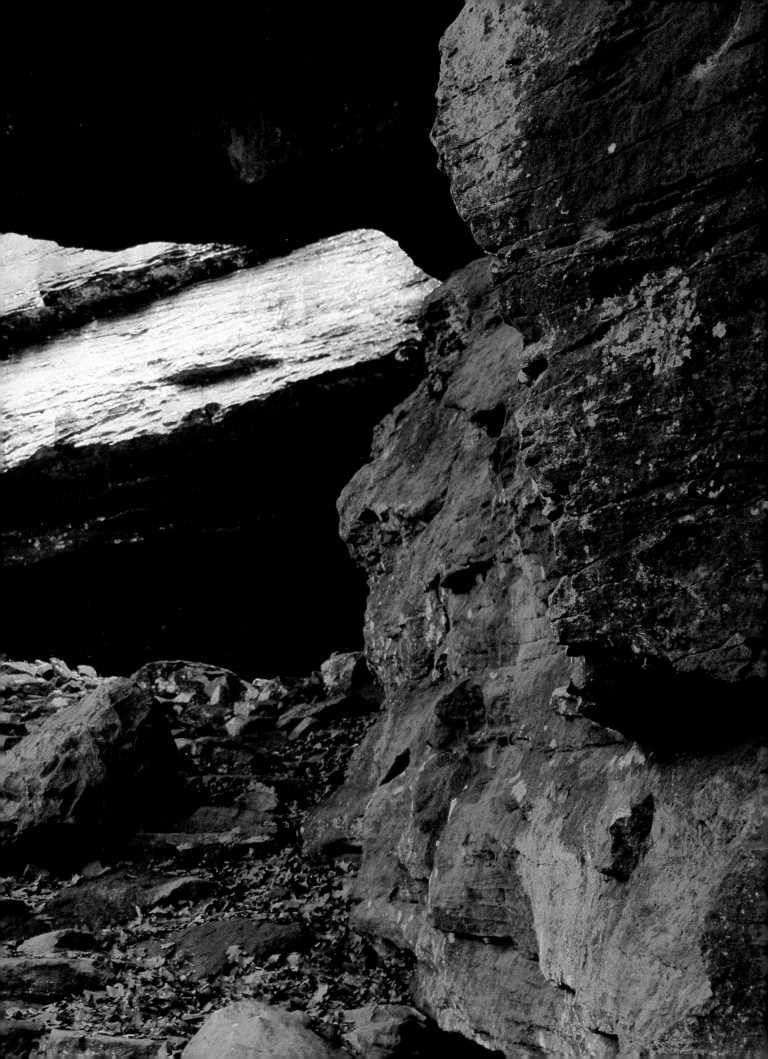

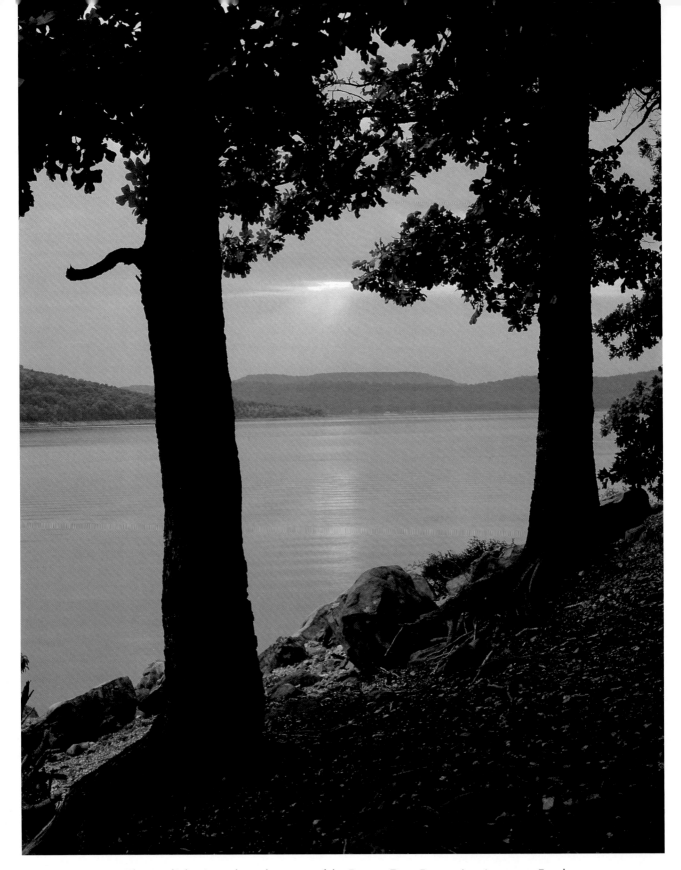

▲ The sun lights its path on the water of the Beaver Dam Recreation Area near Eureka Springs, Arkansas. The uppermost of four dams that impound two hundred miles of the old White River, Beaver Dam was completed and the lake filled in 1964.
▶ The Mount Olive Church sits beside a country dirt road near Boxley, Arkansas.

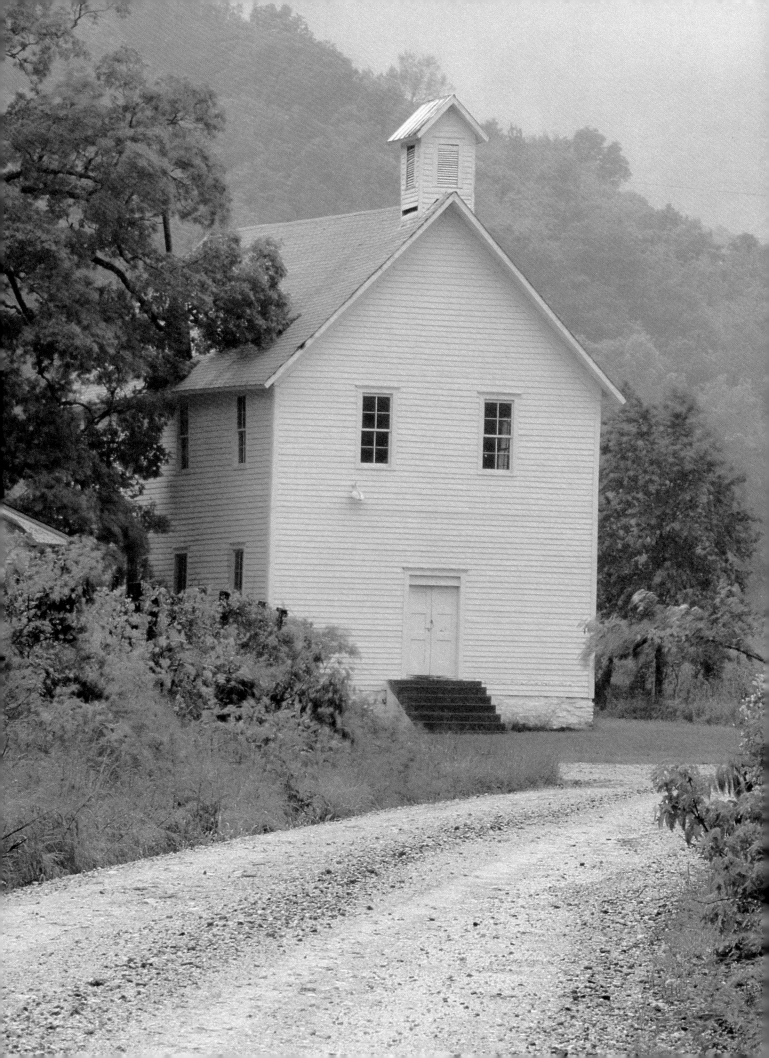

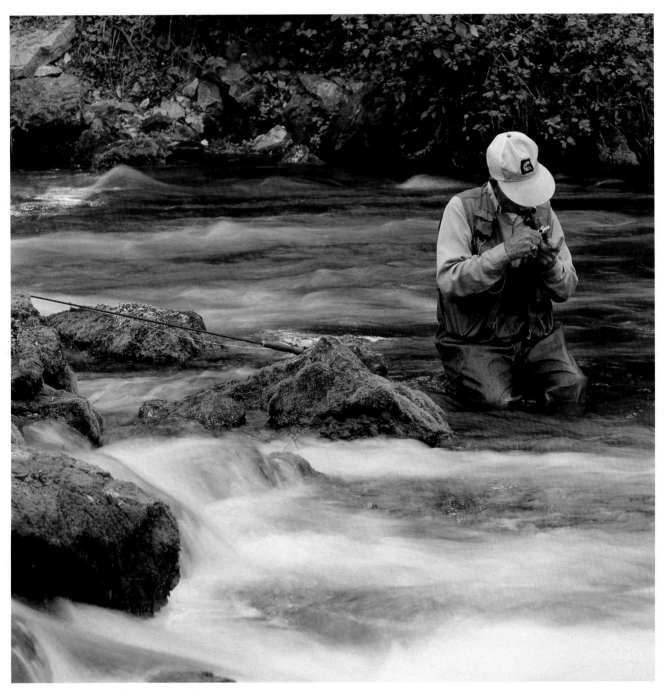

◄ Autumn comes to the Trail of Tears State Park near Cape Girardeau, Missouri. The park was named for the forced march made by the Cherokees from their homelands in the southeast. The trail, on which many died, crossed the Mississippi at this location. ▲ A fly fisherman takes time out at Bennett Spring State Park.

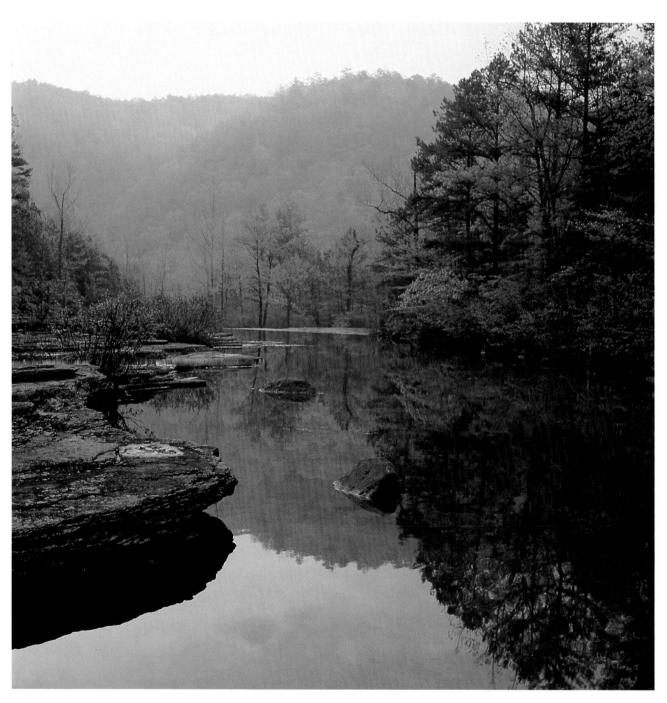

▲ At remote Haw Creek Falls in Ozark National Forest, eight campsites are deemed sufficient for an area of exquisite beauty. Accessible only by gravel roads, Haw Creek Falls is located in Crawford County, Arkansas. ▶ Boat motors are limited to ten horsepower on eighty-two-acre Spring Lake in the Ozark National Forest. The lake is accessible by gravel roads from Dardanelle to the north and Belleville to the south.

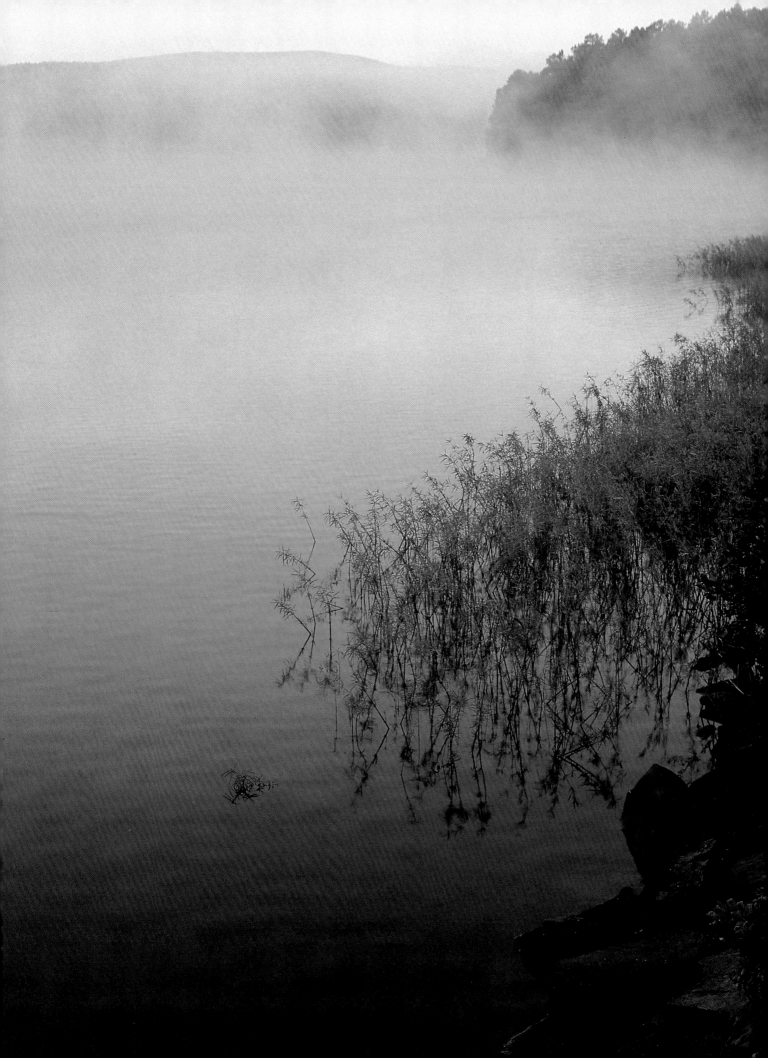

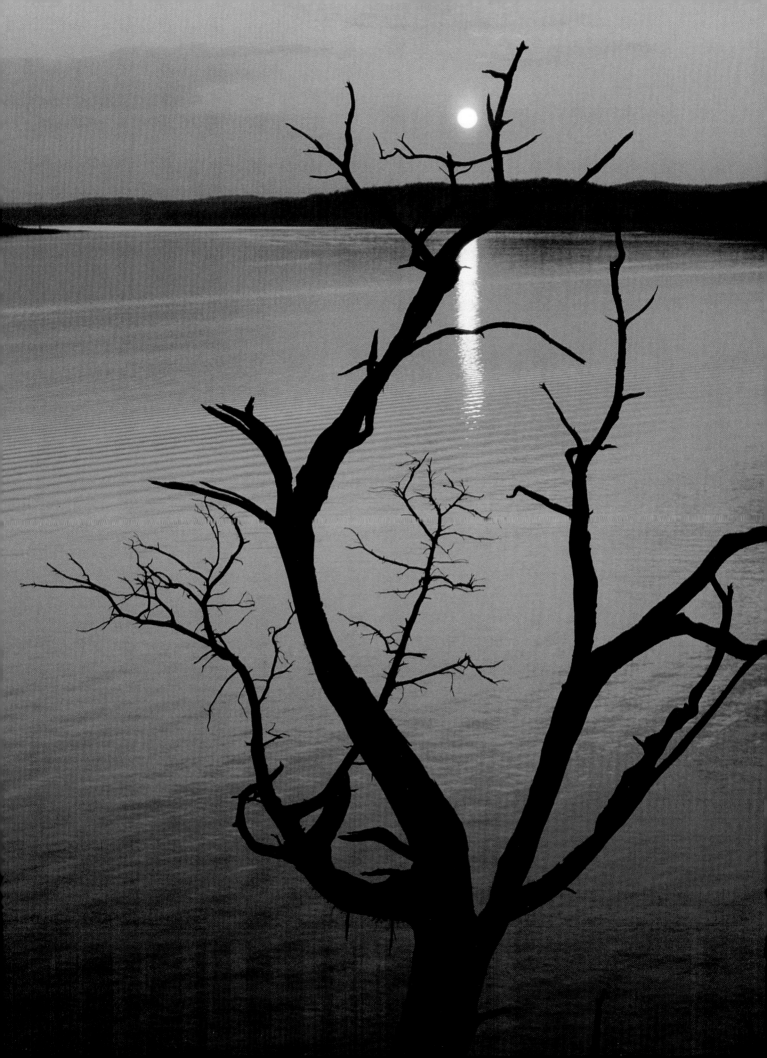

◄ Sunset bestows a golden glow on Bull Shoals Lake south of Pontiac, Missouri. Wriggling along the border between Arkansas and Missouri like a kind of giant serpent, the lake isolates the citizens of one state from each other. A long point below Pontiac is part of Arkansas, but it is accessible by land only from Missouri.
▲ Mountain View, Arkansas, celebrates the Arkansas Folk Festival each year on an April weekend. Folks come from around the world to play and to listen to the music.

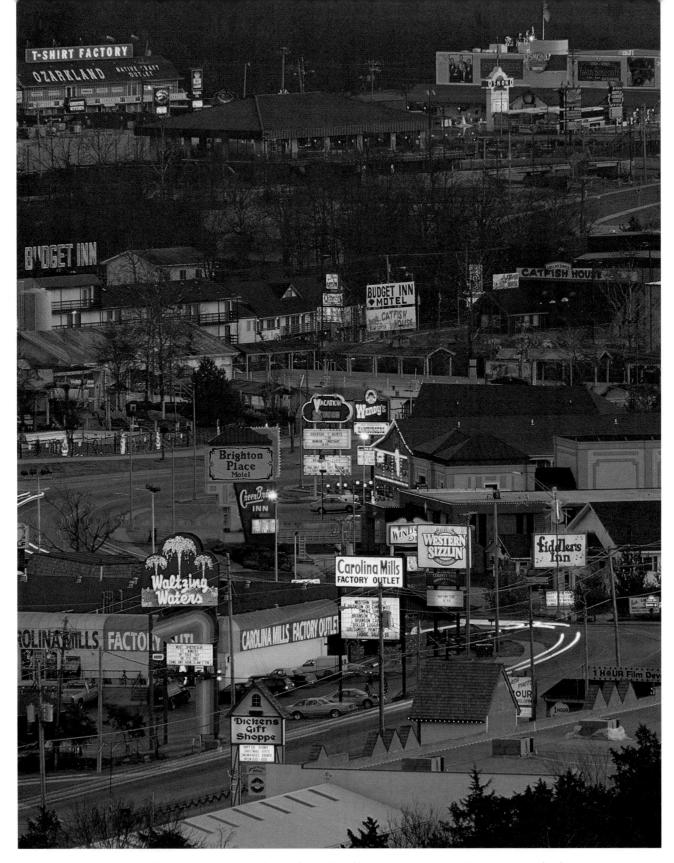

▲ The observation tower at the Ruth and Paul Henning Conservation Area overlooks north Branson, Missouri, to the southeast. Branson, a center of entertainment in the Ozarks, is well known for its family-centered theaters, its arts and crafts, and its music.

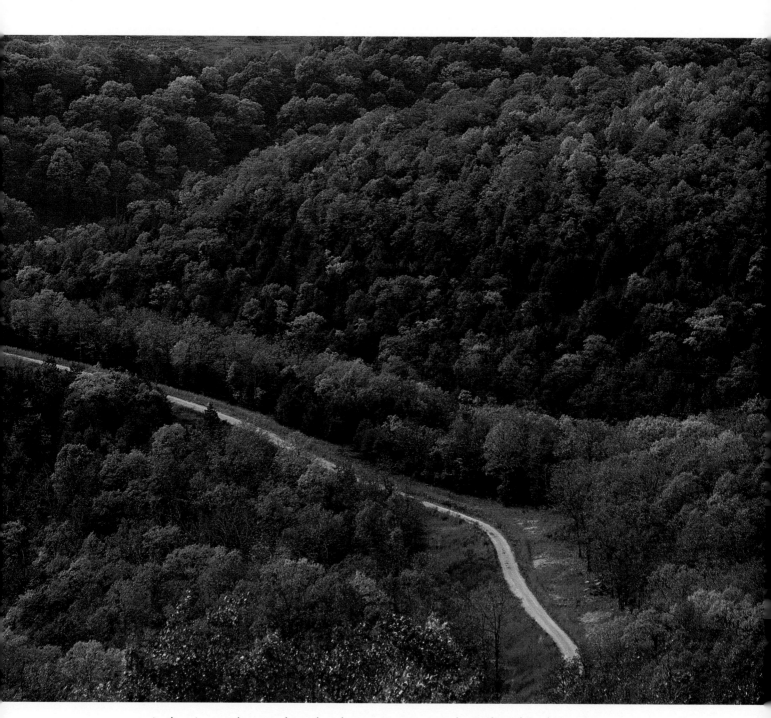

▲ In the view to the west from the observation tower at the Ruth and Paul Henning Conservation Area, one would never know there was a city anywhere within reach. That is one of the special joys of the Ozarks: the solitude of wilderness and the glitter of the city are both readily available. ▶ ▶ Near the Current River, large round bales of hay are popular with Ozark cattlemen, who store them in the open for cattle feed.

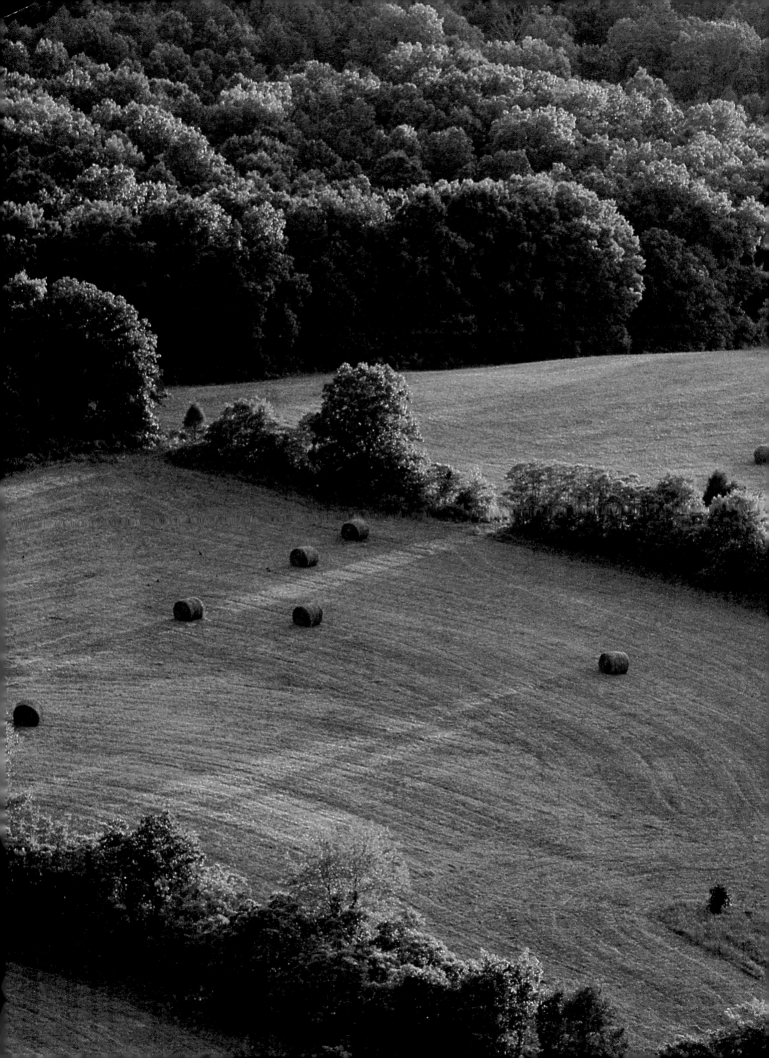

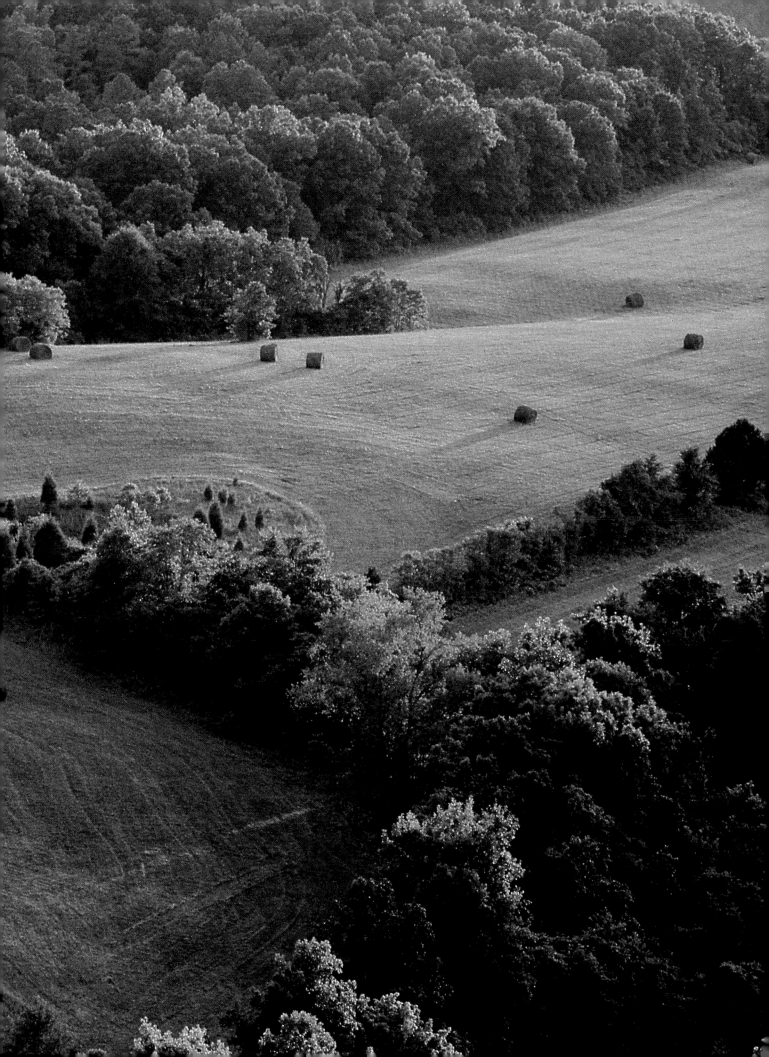

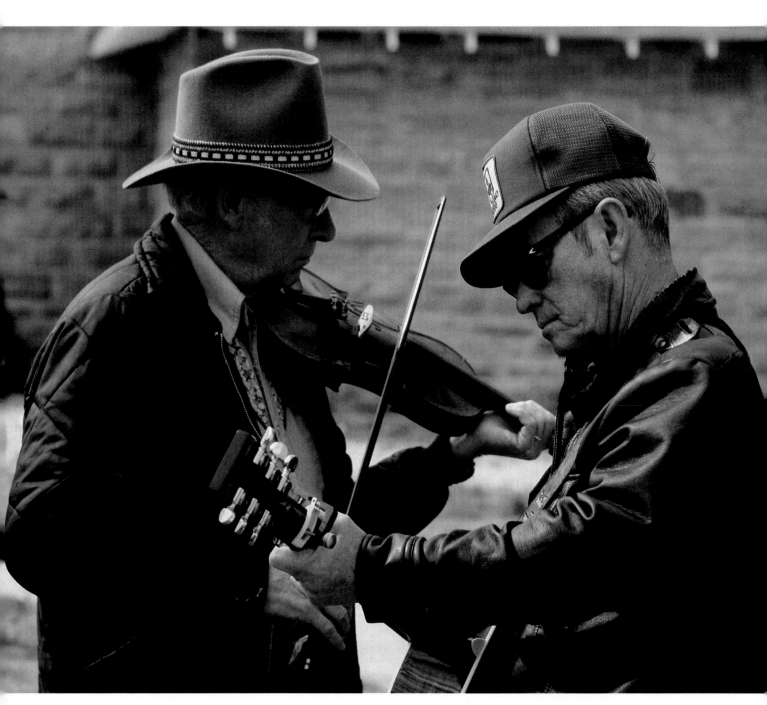

▲ On the courthouse lawn in Mountain View, Arkansas, free folk music is a tradition. In April, the square is filled for the Arkansas Folk Festival. Anywhere the urge to play occurs, impromptu sessions feature a variety of instruments; however, the fiddle is so esteemed that Arkansas designated it the state's official musical instrument.

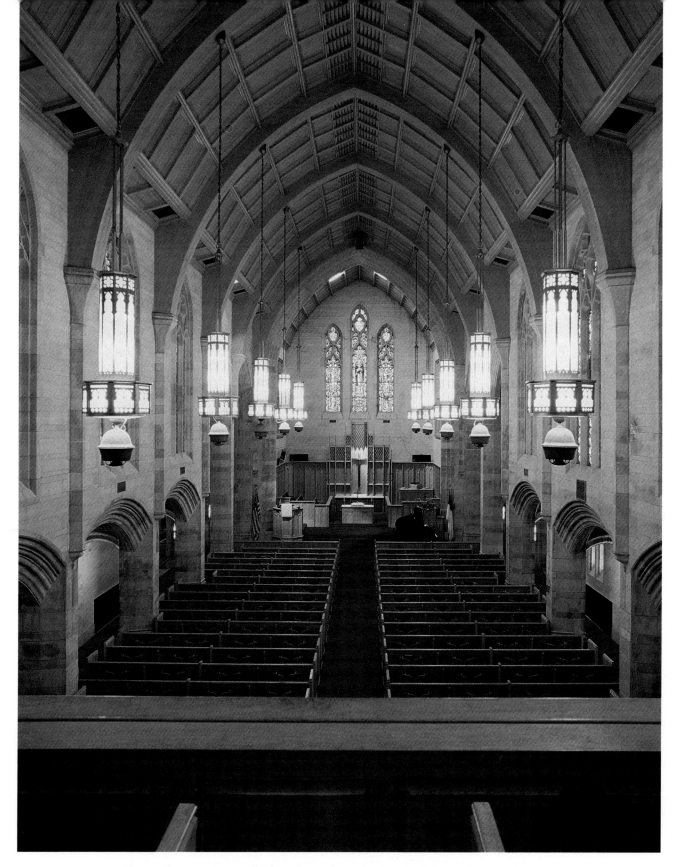

▲ The Williams Memorial Chapel stands at the heart of the College of the Ozarks campus and is the focal point of the spiritual life of the college. Constructed in Gothic style, the chapel measures 150 feet long, 80 feet wide, and 80 feet from floor to ceiling. The stained glass windows, designed to resemble those in European cathedrals, depict a chronological history of the Bible from Genesis to Revelation.

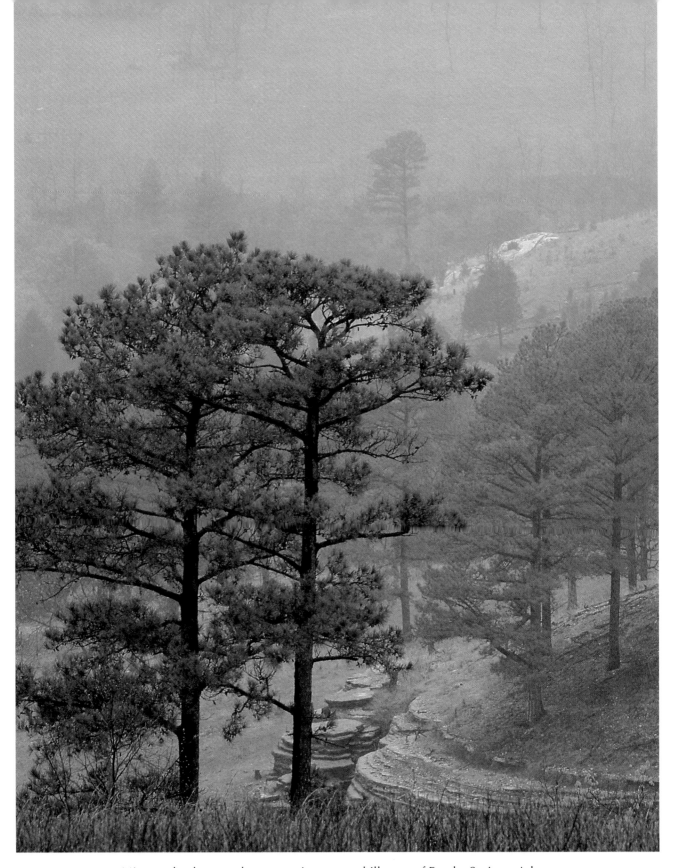

▲ Mist nearly obscures the steep, pine-strewn hills east of Eureka Springs, Arkansas. During the last century, the Ozarks became a destination for some who made the pilgrimage by train to Eureka Springs. The town received its name when the passengers shouted "Eureka!" as they disembarked from the train at their destination.

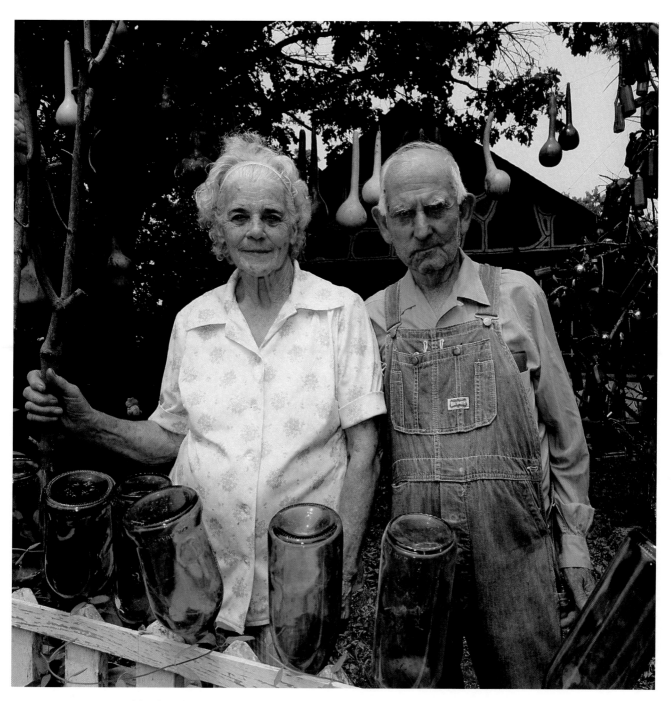

▲ Mildred and Jess Lane have decorated their homestead, situated between Lampe and Kimberling City, Missouri, with colorful bottles and gourds. Such colorful and unique decorations adorn many of the rural homes scattered throughout the Ozarks.

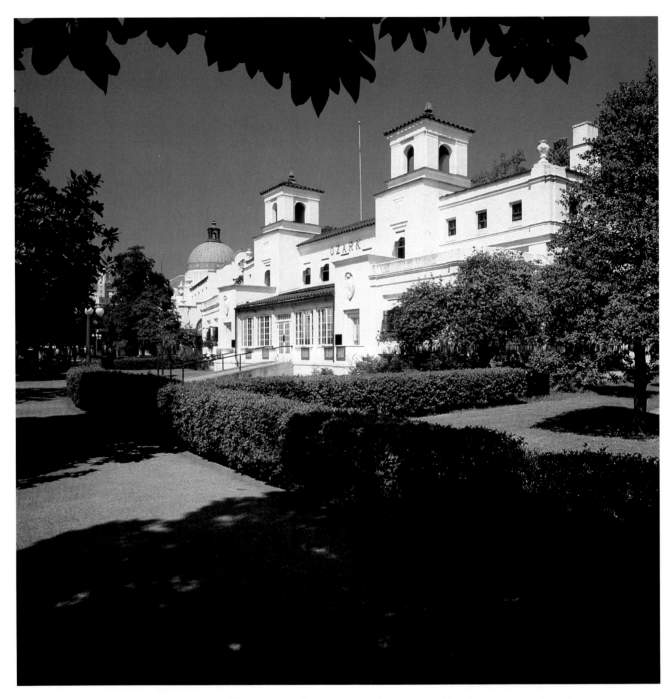

▲ Hot Springs' first bathhouses, crude structures of canvas and lumber, were replaced by elegant buildings in the early 1900s, some of which still stand on Bath House Row. The combined flow of the springs is 850 thousand gallons per day. The water contains traces of minerals and, at 143° Fahrenheit, is sterile. ▶ Lois Dodson quilts at the Ozark Folk Center. ▶ ▶ The White River flows past bluffs of Calico Rock, Arkansas.

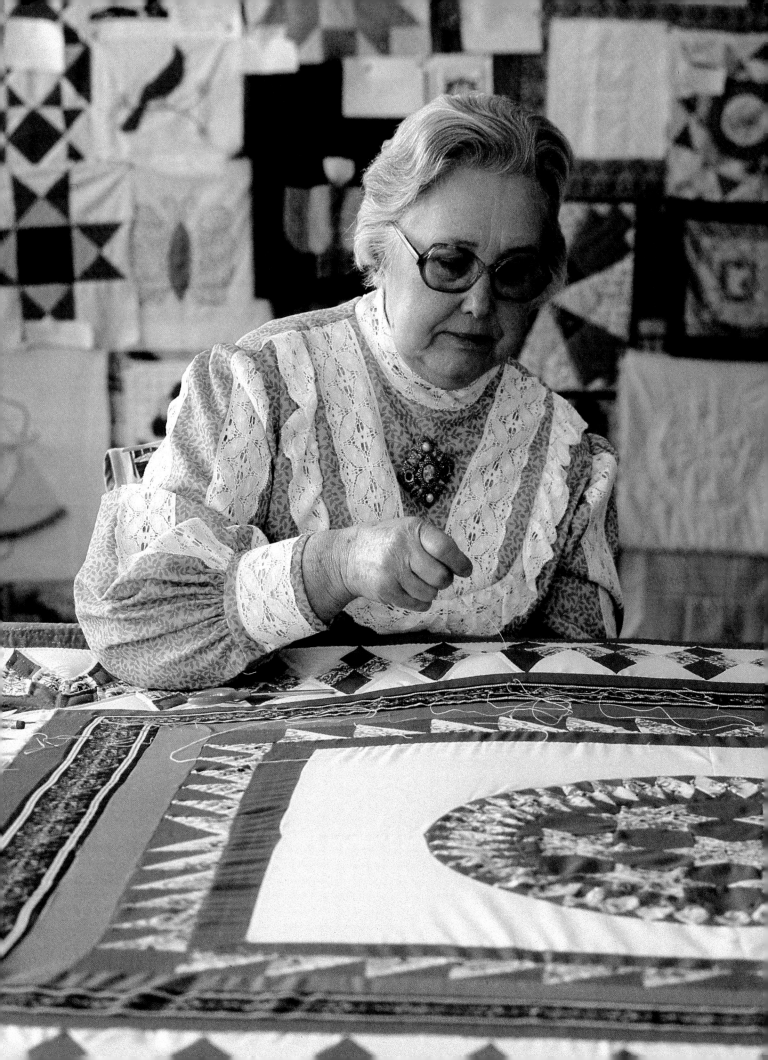

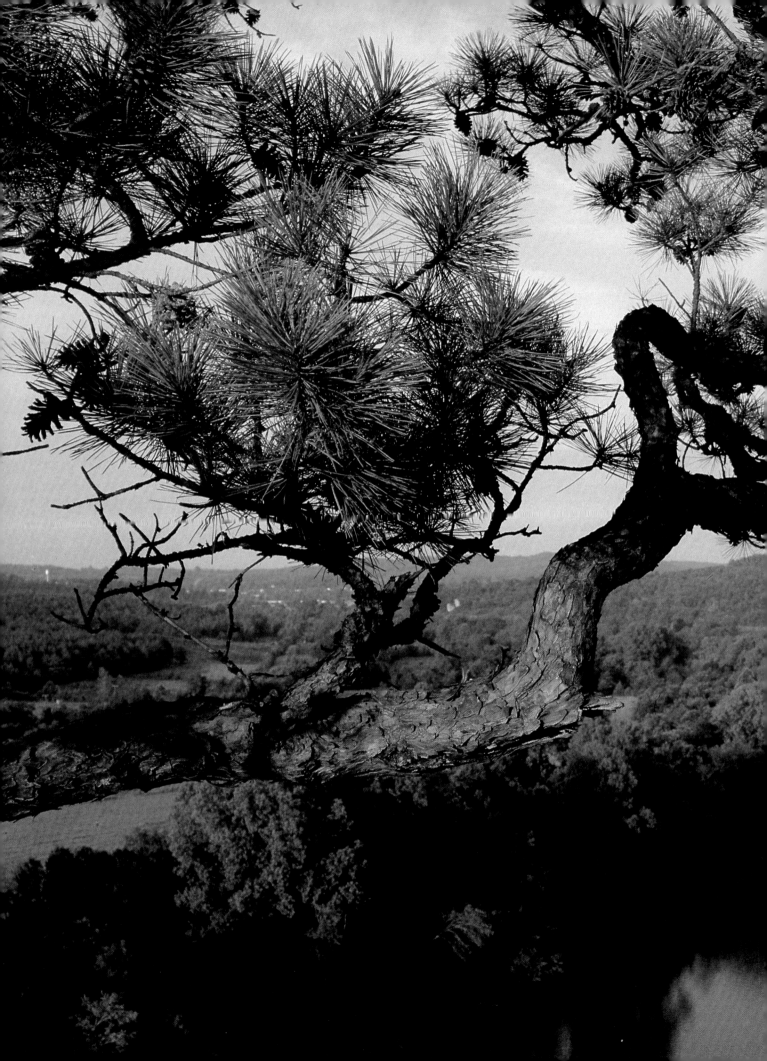

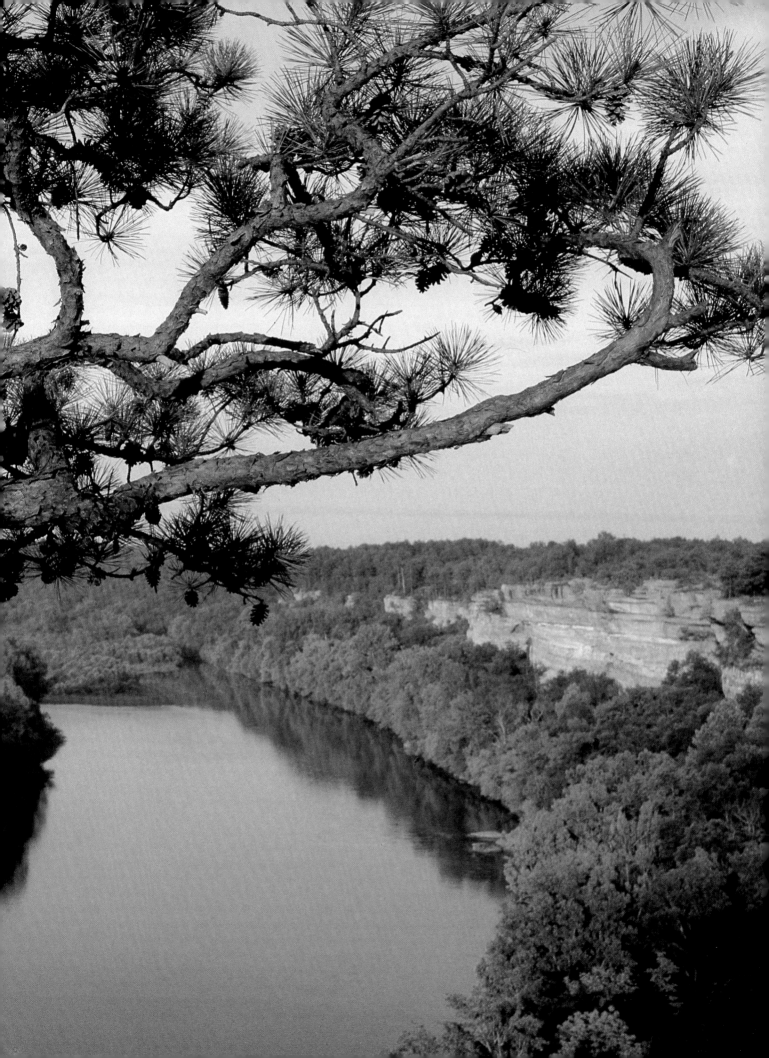

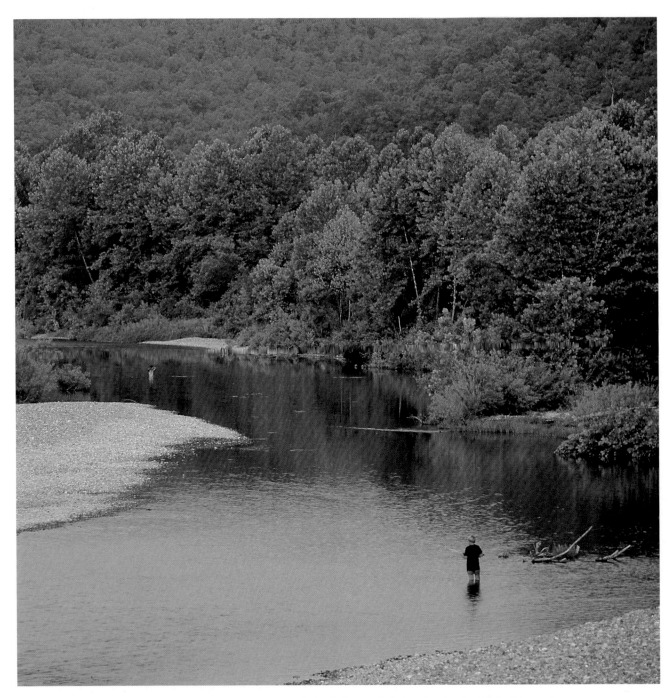

▲ A boy uses the last minutes of daylight to fish in the Jacks Fork River near Alley Spring in Ozark National Scenic Riverways. Smallmouth bass are the piscatorial prizes here, but goggle-eye and sunfish are good, too. ▶ West of Eureka Springs, Inspiration Point overlooks the White River Valley, where homes nestle in the trees. ▶ ▶ Sunrise lends a pink glow to Greenleaf Lake in Muskogee County, Oklahoma.

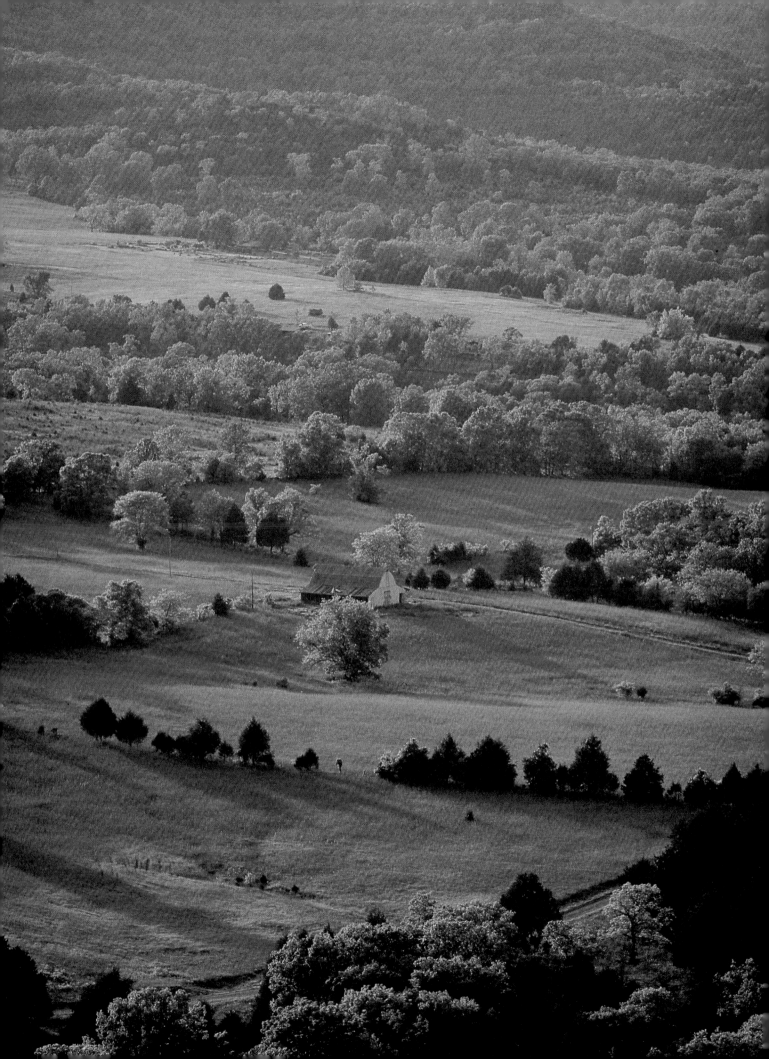

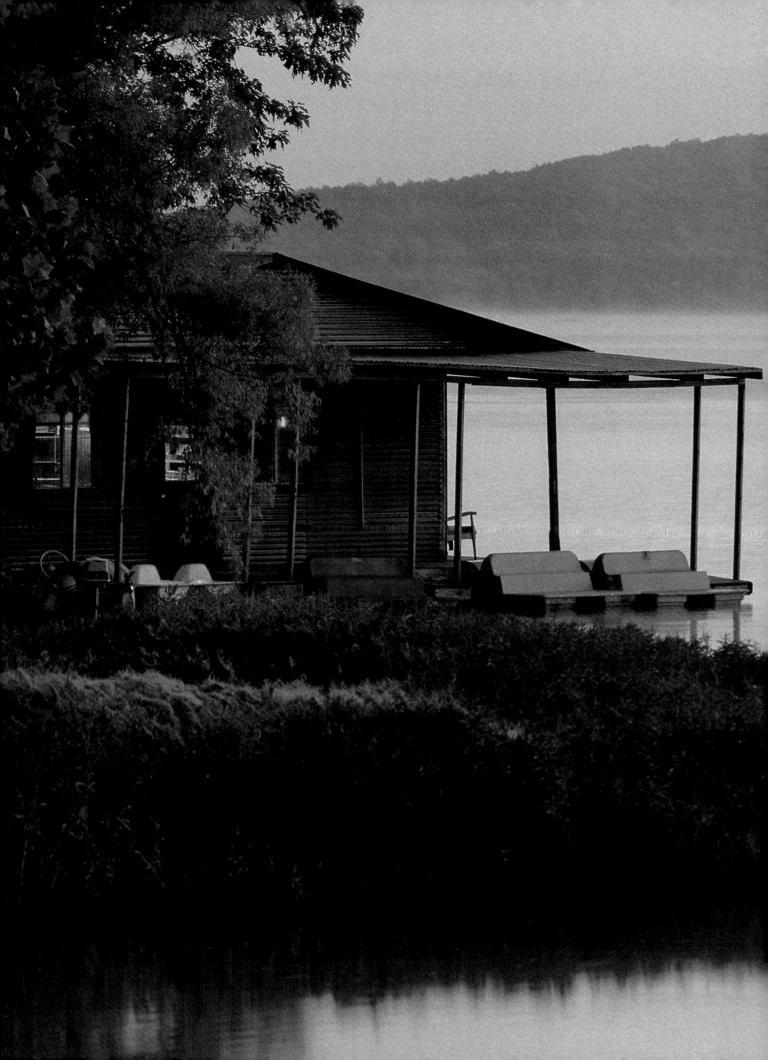